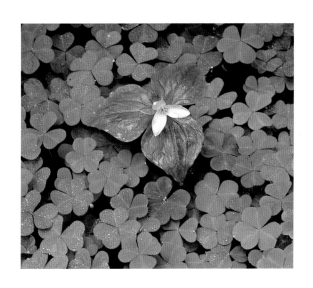

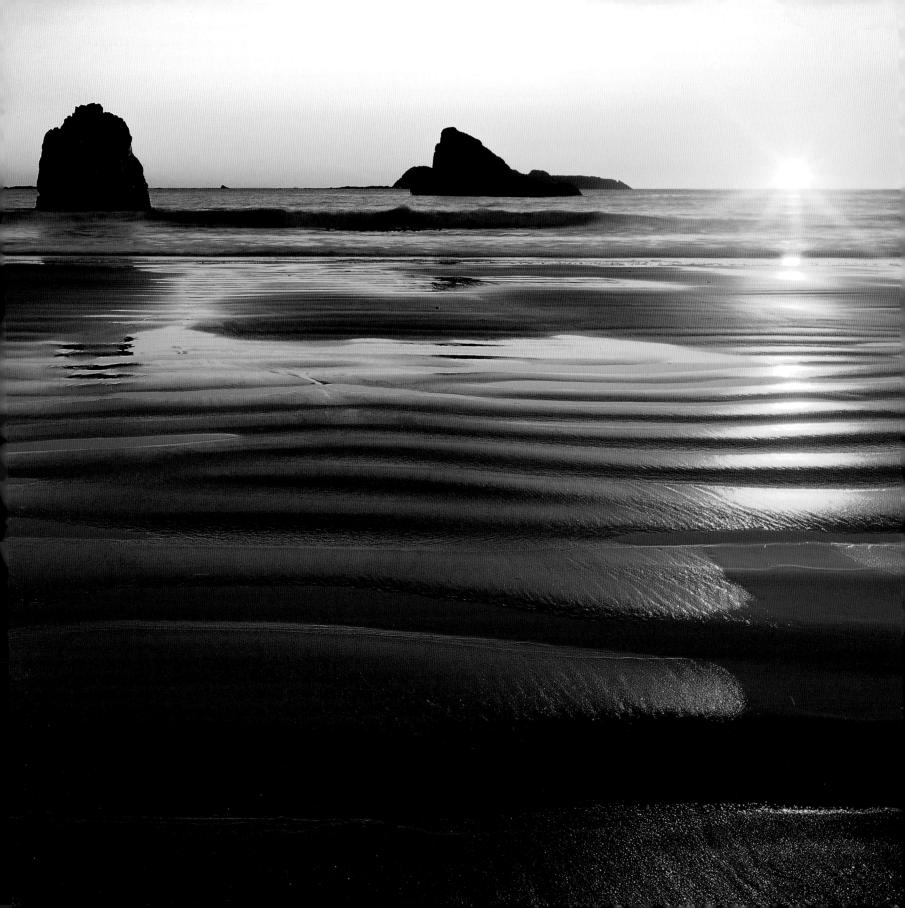

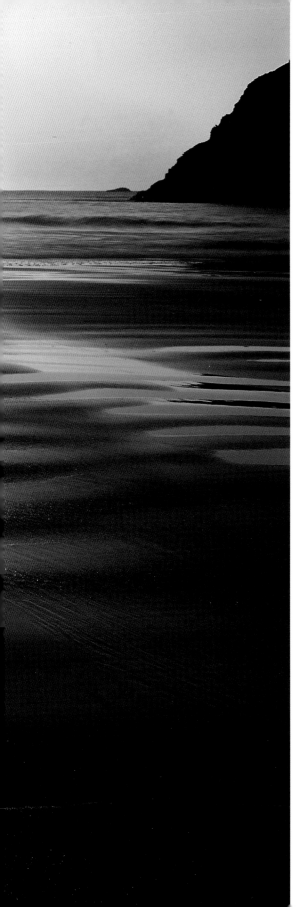

BEYOND THE GOLDEN GATE

California's North Coast

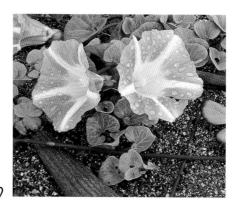

For Mike
our beautiful
North Coast
wrap your mind
around it.

Photography by
LARRY ULRICH

Essay by Roy Parvin

COMPANION PRESS
SANTA BARBARA, CALIFORNIA

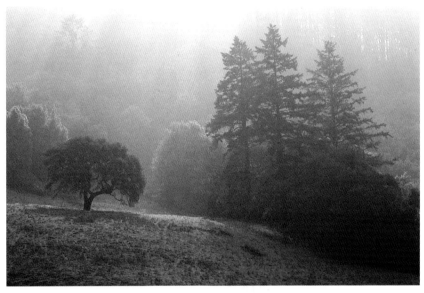

COAST LIVE OAK AND DOUGLAS FIR
Bear Valley Trail, Point Reyes National Seashore

Preceeding page: Sunset at College Cove, Trinidad State Beach;
Beach morning glory at Dry Lagoon, Humboldt Lagoons State Park.
Frontspiece: Western trillium and redwood sorrel along the Boy
Scout Tree Trail, Jedediah Smith Redwoods State Park.

Companion Press
464 Terrace Road
Santa Barbara, California 93109

Jane Freeburg, Publisher

Edited by Mark A. Schlenz
Designed by Lucy Brown
Printed and bound in Hong Kong
through Bolton Associates, San Rafael, California

ISBN 0-944197-57-4 (paperback)
ISBN 0-944197-58-2 (clothbound)

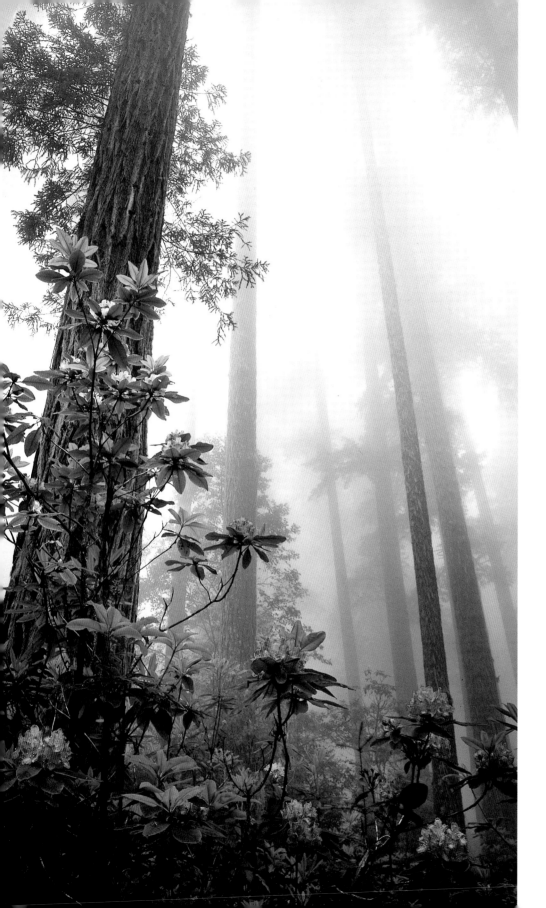

Contents

*Western rhododendrons and coast
redwoods, Redwood National Park*

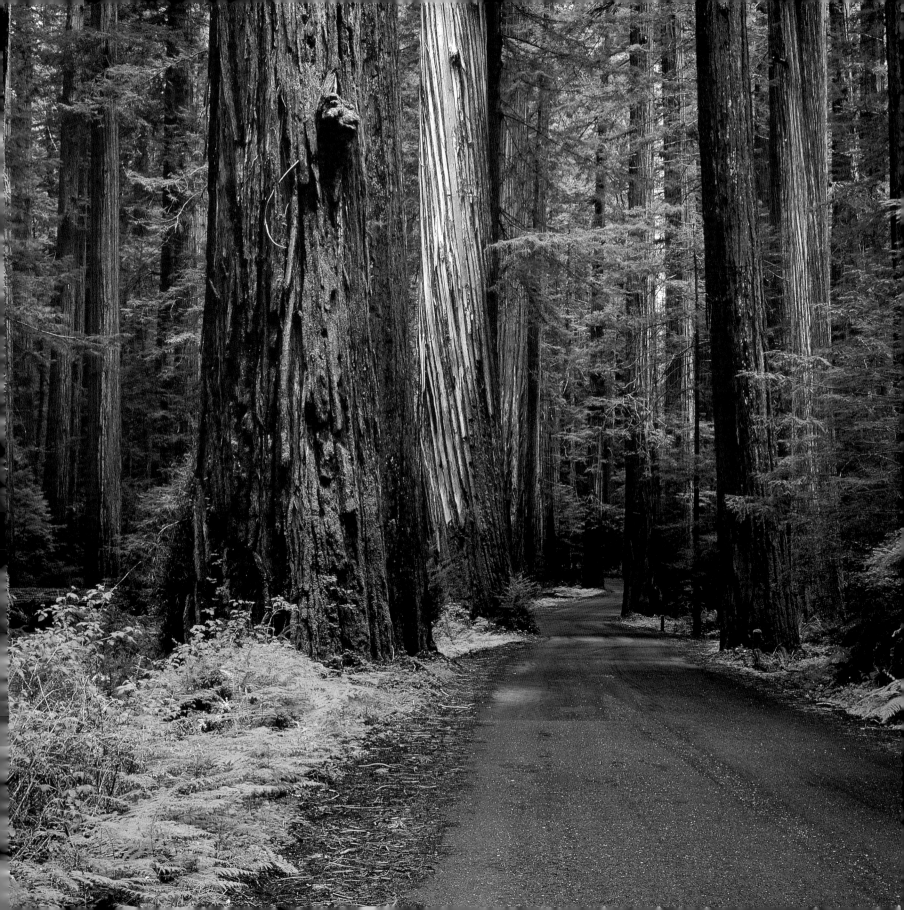

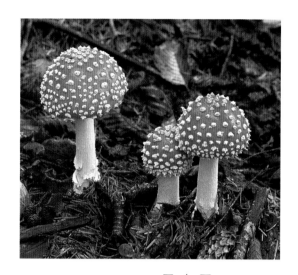

Preface

Left: Coast redwoods line the Mattole Road through Rockefeller Forest, Humboldt Redwoods State Park.

Above: Amanita muscaria emerge from the forest floor, Redwood National Park.

When people ask us, "Where do you live?" we usually get a polite, empty stare when we answer the question. Our hometown is tiny and remote, not really on the way to anywhere. So when a fellow we met fishing one summer in Montana asked us that question, he surprised us. When we replied that home was in Trinidad… (we always add a long pause here so they get to think for a moment that we are from an exotic island in the Caribbean)… California, he said, "I was there once! I saw redwood trees so big I couldn't wrap my mind around them." Oh yes, the North Coast can have that effect on people.

A fascination with those big trees—and the quiet beaches—first lured Larry to Trinidad in 1971. That and a very strong urge to transfer away from the Air Force Reserve base where he was stationed during that agitated part of America's history. Something to do with attending a peace march in San Francisco in his uniform, he tells me, but that is another story. After I met Larry in 1972 we made our home in Trinidad a base for our photographic travels. Not long afterward, after photographing in the redwoods most of the year, Larry told me that someday he wanted to compile his images of the North Coast into a book. He wanted to call it "Behind the Redwood Curtain." One aspect of the phrase refers to a physical element: a mature redwood forest, especially when

shrouded in fog, forms an impenetrable "curtain." Another aspect is more meta-physical—the coastline north of the Golden Gate Bridge has always been mysterious and inaccessible. Not many people knew much about the region at the time, including us.

Skip ahead three decades. (Yikes, has it been THAT long?) We were running a successful stock photography business. We had photographed Oregon, the California Coast, and Arizona for book projects. Three volumes of wildflower books had been produced with Jane Freeburg at Companion Press in Santa Barbara, yet we still hadn't published the North Coast book. So when Jane and her husband, Mark, were up in Trinidad to visit, we caught them at mellow moment.

Purple-sailed jellyfish on Houda Point Beach near Trinidad, Humboldt County.

While sharing a glass of Mendocino Merlot on our patio, our conversation wandered with the wine and Larry asked her if she'd ever consider publishing such a book. Silence. "We'll call it 'Beyond the Golden Gate: California's North Coast,'" he blurted out. WHAT? I'd never heard him use that title. "I came up with it last night," he said. Jane looked at Mark, then back at us, then said the words every photographer dreams of hearing. "That's a great idea."

Long into the next bottle of wine we exchanged ideas of content and scope, laying the groundwork for the project. We decided to use Highway 101 as our director, its tributary highways leading to the coast as our escorts. We

had most of the photographs in our files from the past thirty years of shooting, though we needed a few more to fill in some holes in coverage. After all, this was a compilation. Now we needed a writer. Someone from California. Preferably the North Coast. Before we had a chance to fret about that issue, Roy Parvin landed in our mailbox. Our copy of *Northern Lights*, a journal of essays and poetry published by the Northern Lights Research & Education Institute in Montana, arrived. I had just finished reading Roy's essay, "In the Woods Among the Giants," a meditation on coastal redwood forests and the timber company's role as stewards in those forests. Larry and I thought he might be the writer we were looking for. Before we had a chance to copy the essay and send it to Jane for her reaction, we received a parcel from her. She had sent us a copy of the same article and had written the words, "Do you think this guy would be a good choice for the writer for 'Beyond the Golden Gate?'" on a typically understated Jane post-it note. That was it. After a visit to the local phone book and our phone call to Roy, he agreed to emerge from his woods and fiction writing to collaborate with us.

Unless you live on the North Coast, you may not think there's anything special about this more remote, slower-paced region of the Golden State. That Montana fisherman was unusual because he could recognize the name of a town in northern California. Most people find the names Olema, Petrolia and Manchester (where my grandmother went to grammar school) so foreign they may as well be in Kansas. When the entire state of California is folded into the same mold with Los Angeles, San Diego, and San Francisco, the North Coast just doesn't fit. It's not that we don't like being the outcast—we rather enjoy the anonymity that comes with unfamiliarity. The halves of our large state are like twins separated at birth, not understanding why the other turned out so different. The frenetic, road-raged, traffic-bound shoreline of southern Cali-

fornia is lined with palms. The North Coast is mile after mile of open space, forested hillsides, and rugged coastline, dotted with wineries, rustic inns, and cows. We're related???

Why is the North Coast so special? Maybe it's the environment. Seven major rivers flow through our five north coast counties, nourishing our economy and energizing our souls. Three hundred miles of coastline keep the climate

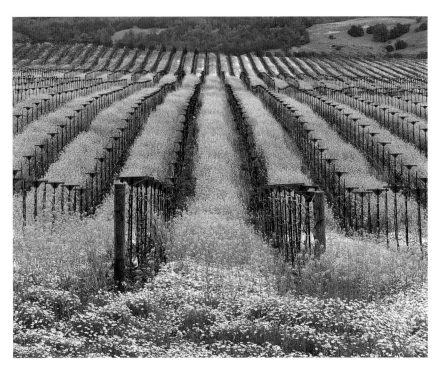

Daisies and wild mustard carpet vineyards in the Alexander Valley, Sonoma County.

temperate and the air clean. I recently read a local visitor guide that stated, "open space isn't the opposite of urban sprawl, it's the foundation of our lifestyle and economy." The pastoral countryside of Marin County greets the battle-weary traveler who has escaped San Francisco on Highway 101, the main artery of the north coast. Grapevines, cradling California's new gold currency in twining tendrils, spring from the rich soil of Mendocino County. Salmon and steelhead, a dwindling resource, still make a valiant attempt to return to spawn in their home streams throughout the north coast. The apple orchards of Sonoma are a rich depository of both familiar and antique apple strains, a veritable outdoor museum of fruit our grandmothers once picked for their children. Clean beaches, the sound of a bell buoy calling out the ocean's mood, and trees crowding the shoreline in Humboldt and Del Norte Counties contribute to the rural atmosphere. Though we are not known for our beaches in a southern California sort of way, we have enough to keep surfers,

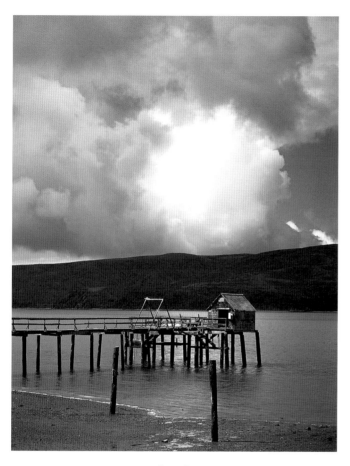

A fishing dock in Tomales Bay, Marin County.

joggers, and a whole kennel full of dogs happy. Our cities are reasonably sized and our traffic jams are manageable (well, Santa Rosa is learning to be an exception).

Maybe it's the people. Long before Jedediah Smith stumbled through the redwood forests, Native American tribes flourished along the North Coast. Then and now, their presence enriches our lives and gives character to this place. Newcomers have helped shape this place, also. All along the coast are individualists who love the region but couldn't find jobs. To stay, they have made their own occupations as entrepreneurs. Some turned hobbies into a businesses—wineries and microbreweries are scattered along the northcoast like twist-off bottle tops at a company picnic. Outdoor equipment manufacturers located on the North Coast and began pumping out quality products known throughout the nation. Specialty food makers could fill a supermarket aisle with hot sauces, mustards, soyproducts, and sweets. I once read that the North Coast has more artists making a living at their art than any other region its size in the nation. Creative people—painters, glassmakers, jewelers, potters, even writers and photographers—live on the North Coast because they can. Some of these creative folks are responsible for our more unusual public events: a Ferndale artist conceived the Kinetic Sculpture Race, where people compete "For the Glory!" (their motto) by maneuvering their people-powered contrap-

tions across sand, water, and asphalt over a grueling three days. The renowned Banana Slug Races in Prairie Creek Redwoods State Park bring slug lovers and slime-removal stations together in a day of action-packed fun. Del Norte County's annual crab races (and dining afterward) attract thrill-seekers from throughout the state.

Larry and I feel lucky that we not only found each other but that we found a spot to live that "calls" to us, a place we can speak of with longing, a home environment we feel bound to. True, the North Coast is not for everybody. The Rolling Stones have never played here—but The Grateful Dead have. It takes a *lot* of rain to grow these tall trees. Earthquakes, floods, and tree-sitters get us on the evening news. But if our photographs and words in this book convey the sense of place that we feel, then Larry and I (and Roy, Jane, and Mark) have done what we set out to do with this book about our home place.

Welcome to three hundred miles of coastline and two million acres of forest. Marin, Sonoma, Mendocino, Humboldt and Del Norte—five out of fifty-eight counties in California. Wrap your mind around it.

–Donna Bacon Ulrich

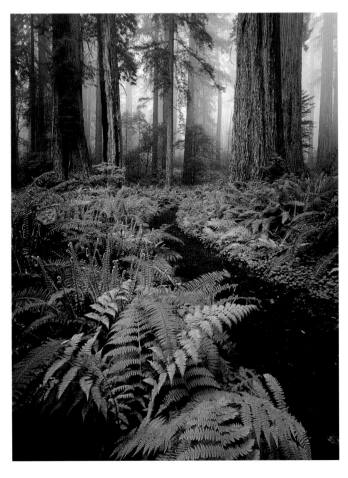

A fern-lined trail in Lady Bird Johnson Grove, Redwood National Park, Humboldt County.

Opposite:
Cape Vizcaino and the Lost Coast from Westport-Union Landing State Beach, Mendocino County.

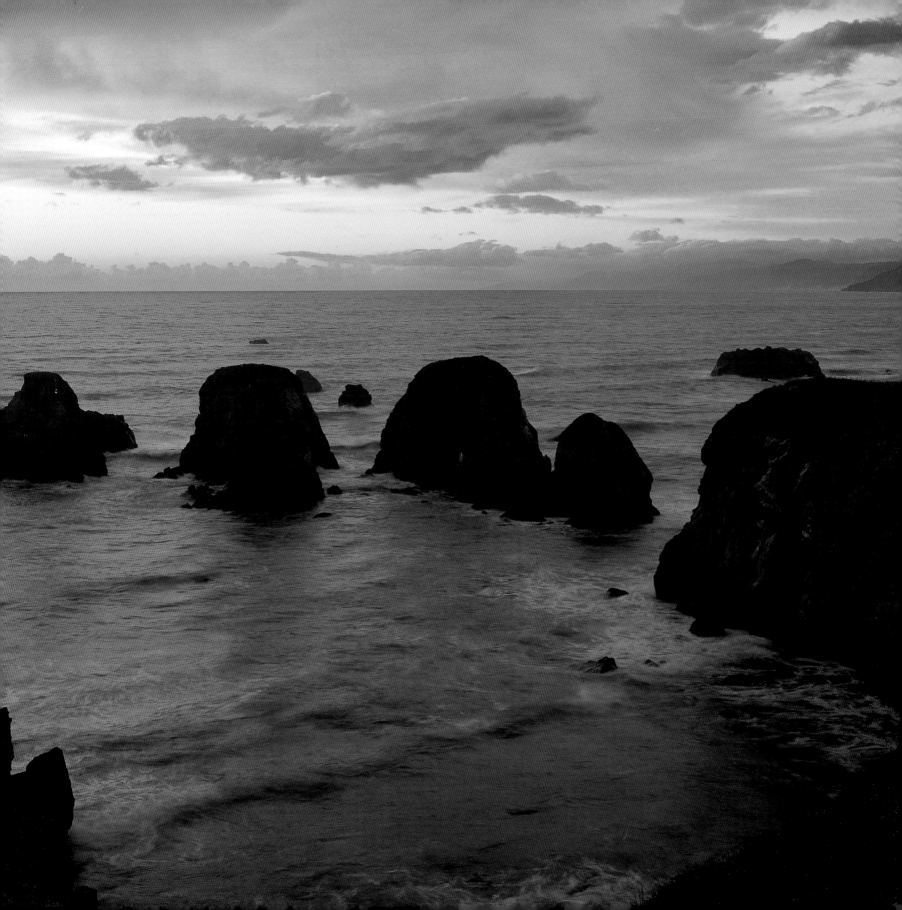

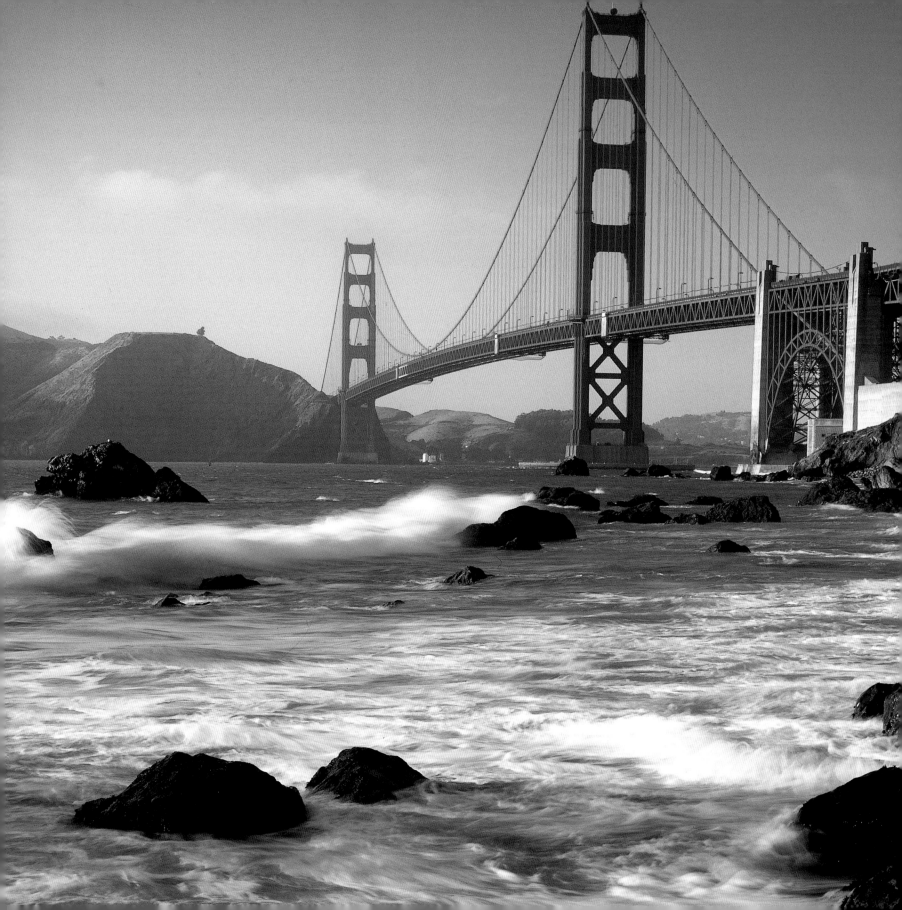

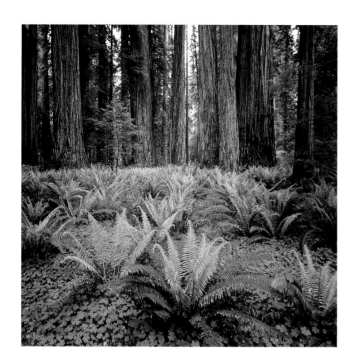

North of the Golden Gate

Opposite: Golden Gate
Bridge from Baker Beach,
Golden Gate National
Recreation Area,
San Francisco.

Above: Redwood sorrel,
sword ferns, and majestic
coast redwoods, Jedediah
Smith Redwoods State
Park, Del Norte County.

M y home is in the woods, a five-acre dell in timber country, the surrounding hills a curtain of redwoods. The property is at the end of the road, up a hill that dodges the trees of the forest, a place so concealed by branch and trunk most people in the nearby town don't even know it exists. It's a good place to write, the rest of the world kept at a distance, only the immediate one remaining—that and whatever fictive world currently occupies my imagination. Not far from the deck of my writing shack, a nearby redwood reaches upward like a massive arboreal guardian.

I've lived here in the woods long enough that even the idea of a city can seem impossible, the glut of traffic, houses chockablock on top of one another, the ceaseless hum of urban life. I have to remind myself that two hundred and fifty miles due south from my hideout there is indeed a city: San Francisco. The City as locals would have it, as if there is any other.

I lived in San Francisco long enough—fifteen years or so—to call it home. North of the Golden Gate was territory I discovered gradually, first on the saddle of a mountain bike. I would steal off in the early weekend hours while

the rest of San Francisco slept, point the car north, set out for the unknown: Mount Tamalpais, the green deeps of Muir Woods, the humped hillsides of Olema above the ragged Pacific. I shared the wilds with hikers enjoying a ramble and the occasional rider astride a horse. I traded favorite trails with other mountain bikers I encountered. In time, I covered almost every backroad, overland route from the freeway to the ocean, finding along the way a place before city grids and mass transit, somewhere as yet "unimproved" by urban planners. In the dozen years since then, much of Marin County's open spaces have been gutted and carved into golf courses, condominiums, strip malls—so great is San Francisco's magnetism that the overflow has migrated to what was once considered the far edge of its realm.

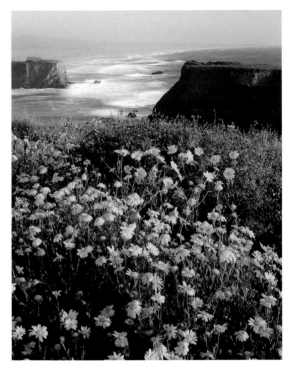

Wildflowers bloom on headlands, Mendocino County.

The green, wild places still exist in Marin County, but you have to know where to look. In fact, the farther north of San Francisco you venture, the more wild places there are to discover. You'll discover, too, that the tug of the city eventually recedes until you find yourself in a place that moves more to the pulse of seasons than to tsunami tides of rush-hour traffic.

What lies north of the Golden Gate to the Oregon border defies ready categorization. Every handful of miles the land seems to miraculously remake itself, from hewn seascapes to rolling dairy farmland, ancient forests to quaint Victorian villages. Somehow, the evocative photography of Larry Ulrich captures every nuance of this far-flung region. Larry is able by some trick of technique—or maybe it's magic—to get to the heart of a landscape; even the smell of the place seems to lift off the page. His photographs in this volume represent a pictoral journey which starts in Marin County and continues to

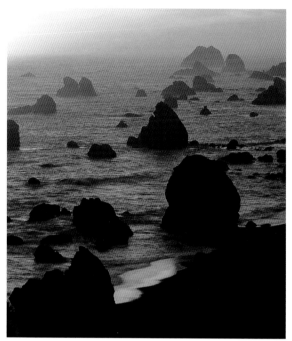

Seastacks at sunset, Shell Beach, Sonoma Coast State Beach.

climb north, up through Del Norte County, the high shelf of California. You will trace the jagged coastline of the Pacific, traverse the inland territory nearby, where 101 is not a vehicle-choked superhighway, but a meandering two-lane road in no rush to get anywhere. Every time you revisit these photographs, you will find something new. Perhaps one tiny moment registered on film might inspire you to investigate beyond the Golden Gate on your own.

The Northern Coast

Looking at a map, the coastline above San Francisco appears as if it has been hacked out by a dull knife, a fair approximation of the effects of ocean meeting land. The mapmaker's task is always a provisional one, recording shifts and reshifts of continental mass. Until the ballyhooed big one hits—the earthquake everybody knows hangs over the horizon of future like an unseen wave—when California will reportedly slide once and for all into the drink, until then you can depend on a wonderfully crenellated Pacific shoreline, full of hidden beaches and estuaries.

Back in the days when I lived in San Francisco, I used to camp in Kirby Cove, a small spit of beachfront right under the Golden Gate, a strangely divided vista if ever there was one, the lights of the city blinking in the dark, the orange superstructure of the bridge arcing overhead, the immediate thickets of Monterey pine and eucalyptus protected in the Golden Gate National Recreation Area. At first light, when I woke to the lowing of foghorns and the slow progress of fishing vessels churning in the pearly mist out to the slate-gray Pacific, I could almost forget I was only a few fractional clicks

north of the San Francisco County line.

Pacific is something of a misnomer. The stretch of ocean that washes onto northern California beaches is notoriously treacherous, the riptides strong enough to yank the most experienced swimmer out to sea. Come winter, storms sweep in from Hawaii and along with them, waves of epic proportions. Great white sharks scavenge these cold waters as well, in one recent instance pursuing a surfer into the shallows near Red Rock Beach.

Stinson Beach from high on Bolinas Ridge, Mount Tamalpais State Park, Marin County.

From the window of an auto motoring the coastal highway, however, the Pacific is a most welcome companion. Highway 1 forks off to the coast only a few miles up from Kirby Cove, climbing the shoulders of Mount Tamalpais, then descending to the ocean. The route is not a thoroughfare designed for making time. It shadows the accordion folds of shoreline in sudden dips and rises and corkscrew turns, a feat of engineering that, at times, makes Highway 1 seem more roller coaster than road. The frequent pull-outs are an invitation to park roadside and drink in the stirring panorama of land meeting sea—or perhaps, if it's a more proper drink you're after, a pint of ale and a game of darts at the Pelican Inn, a reconstituted English roadhouse at Muir Beach.

If you have the time and inclination, an excursion to the northern limits of Highway 1 is a slow ride through rugged, dramatic paradise. What can be found is a throwback: sleepy beach and artist communities where the spirit of the sixties continues to invigorate. In the back of a curio shop in Stinson Beach, I recently uncovered a rack of vintage macrame. A few more miles further north, the WELCOME TO BOLINAS roadsign often mysteriously disappears, a form of silent protest against unwanted tourism, although, from

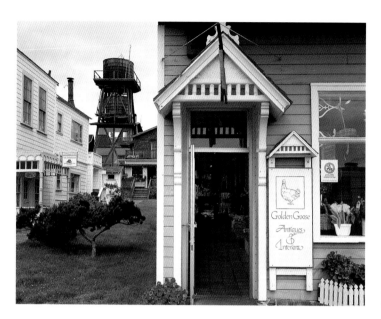

Water tower and village shops in the historic town of Mendocino.

personal experience, I've always felt quite welcome there.

At the northern end of west Marin County, Point Reyes National Seashore juts into the Pacific like the keel of a boat. The Point actually resides on a different tectonic plate than the entire continental United States, separated from the rest of the coast by the infamous San Andreas Fault which runs like a crease under Tomales Bay. The whole peninsula, in fact, has drifted north and attached itself to Marin County; accordingly, its geology its quite different from neighboring inland areas. Within this immense preserve is a remarkable variety of landscapes—rolling meadowlands, dense thickets of forest, marshy estuaries, and miles and miles of deserted beaches. In early spring, the promontories overlooking the Pacific are prime vantage points for viewing the whale migration north.

After Point Reyes, traffic dwindles to a trickle, the marine outposts of western Sonoma County few and far between after the resort town of Bodega Bay, where Alfred Hitchcock filmed much of The Birds. Gualala is the first town that boasts more than a gas station and a few crossroad stores. A bit further up the road is Elk, a lovely little jewel of a place situated in a high perch of cliffside over the ocean, a haven for poets and artists and dreamers. A friend who lives there has regaled me with accounts of the annual parade, a march up the one-block length of Main Street; the event might be short on distance, he tells me, but definitely long on personality.

Not until the tourist draw of Mendocino can traffic on Highway 1 be considered anything more than occasional. It's often said that Mendocino

reminds of a New England fishing village. True enough, as far as it goes, both places full to brimming with wind- and brine-battered charm. But for my money, the tiny village of Westport above Fort Bragg, situated where Highway 1 noses north and east to rejoin 101, fits that bill more precisely, the salt box houses and bungalows that could have been lifted entirely from Cape Cod.

Black Sand Beach near Shelter Cove, King Range Natural Conservation Area, Humboldt County.

The coast, of course, continues above the departure of the coastal highway to the east, but you won't be able to drive much of it. This region straddling upper Mendocino and lower Humboldt counties, known as the Lost Coast, comprises the largest roadless area along the California shoreline. In a jeep you can manage some of the rutted dirt trails for a distance. But to really get anywhere, you're going to have to rely on your own two feet, a strenuous tramp well worth the effort. The hike down the King Range descends more than three thousand feet in three miles, the highest dropoff to the ocean on the west coast, the trailway stepping down through the entire succession of coastal arboreal vegetation, from ridgeline old growth Douglas fir at several thousand feet, down through redwoods to coastal scrub and, finally, the wind-scoured beach and the blue plane of the Pacific.

For all the countless miles I've logged along the crannies of the north coast, I'm still probably most familiar with the marine environment by way of my stomach. I regularly enjoy oysters plucked in the waters off Arcata, from the depths of Humboldt Bay. Noyo Harbor in Fort Bragg is home to the largest fleet of commercial fishermen between San Francisco and Eureka, the off-shore waters featuring an abundance of salmon, red snapper, and halibut. I have my own fish stories to tell, in particular, the happy memory of hooking

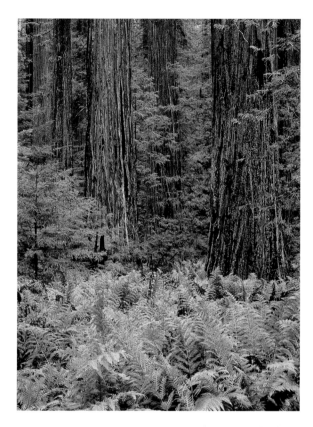

Chain ferns and coast redwoods, Montgomery Woods State Reserve, Mendocino County.

a steelhead during a driftboat expedition along the Klamath, a strike that hit like a handful of dynamite.

As I write this, in early December, the Dungeness crab season is underway, the fishing boats venturing out to sea only after haggling with the commercial buyers over the price of the catch. By now, makeshift shacks are popping up roadside, the kind that hawk fireworks during the summer, though at this nub-end time of year they feature steaming kettles filled with crabs. In most parts of our country, Christmas dinner is turkey or ham or maybe roast beef. But in my particular corner, in central Humboldt, the holidays are celebrated with freshly caught local bounty.

THE WOODLANDS

When I walk through a grove of old growth redwoods, it's not too difficult for me to imagine the coastal forest that once stretched from the Monterey Peninsula north to the Oregon border. Only a few pockets of the ancients remain, the last of the primordials.

I find it hard to deny the pull of such a redwood grove. Underneath the sky-scraping canopy of green, sunlight barely reaches the ground. What light is cast down paints a time when the earth was still young. In the damp, charged air, the stupefying math is inescapable: the two-hundred-foot grope toward the heavens, the thousand years under the belts of bark.

Even with its dwindling ranks, the fabled coastal redwood, *Sequoia sempervirens*, continues to characterize the woods of far northern California—although it's but one tree in the forest. Stands of primary growth Dou-

glas fir in northern California boast their own singular majesty. The irregular crowns of bishop pine populate the marine fog belt of Tomales Bay. Until only a few years ago, the world's most massive madrone stood along a country road between Honeydew and Petrolia in southern Humboldt County. It fell not by a timber harvester's chainsaw, but in the teeth of a nasty winter storm.

The redwood owns our imagination probably because it is so exceptional in practically every aspect, even when the tree is no longer rooted in the earth. A carpenter friend tells me that redwood is practically impervious to water; that unlike most milled timber, it can maintain structural integrity years and years after submersion. Another friend in the trades shares the fact that wood-boring insects avoid redwood like an allergy, something to do with its tannic acid content. No wonder redwood is treasured for use in construction—for joists and beams, fences and decks, siding and shingles. The species reminds me of gold: a rare commodity prized for its broad range of applications, excelling in practically every purpose asked of it except fuel in a woodstove: it burns too hot and fast to sustain a reasonable fire.

I can't say I've ever hugged trees, but I do enjoy standing next to them, the deep mystery that inhabits a pristine forest. I have enormous affection for logging, as well, especially its history and lore. Back in the days before the advent of the chainsaw, felling the giants was a task as Herculean as the tree itself. Teams of men would erect springboard skirting around the trunk, then

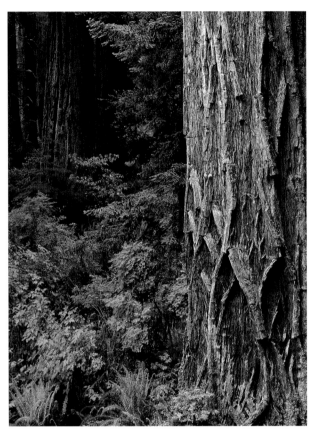

Coast redwoods, Smith River Forest, Jedediah Smith Redwoods State Park, Del Norte County.

A redwood snag stands sentinel along Highway 101 north of Trinidad, Humboldt County.

mount the platform to wield double-bitted axes and employ the long sweep of crosscut saws known as misery whips to bring the big sticks down.

The redwoods on the property that shade my writing shack are secondary growth. A handful of stumps from the old growth woods still thrust upward, notches cut out of the trunk, footholds for the crews to climb up to their scaffolding, the tops of the stumps themselves large enough to accommodate a bear family on a picnic. It saddens me that all I can do is imagine the enormous heft of such a beast on my property. Even so, I cannot fail to consider—and admire—the ingenuity it must have taken to lay such a tree low.

The question of the disposition of the old growth forest is, well, for want of a better word, a knotty one. It is easier to demonize both sides of the argument and that's largely what's happened in the media. Environmentalists are characterized as bands of daffy terrorists, timber crews painted as greedy roughnecks intent on scalping the earth. Either broadstroke serves to divide more than clarify.

I suspect that beneath the salvos fired from both sides, there is more common ground between these two camps than conventional wisdom holds. The timber fallers I know have a deep, abiding love for the outdoors, a discovery that surprised me with a lightning-snap of revelation. Much more than the pursuit of money, nature is the engine that drives their lives, what led them to the forest.

The loggers I know have scant affection for the prevailing cut-and-run harvesting of the large timber companies. Rather than defend such practices they fondly hark back to the old days when the method of operation was sustained growth rather than clearcut, refoliation instead of deforestation.

The loggers tell me this *sotto voce*, glancing over a shoulder to make sure nobody else can hear, a wistful look in their eyes, a gaze that's as inward as it is outward. At such moments, the lines blur and all I can see is heartbreak, what a heavy burden it must be to work in the woods, performing a job you love for a company that's more bully than proper steward of the forest. You should have seen it when, they say.

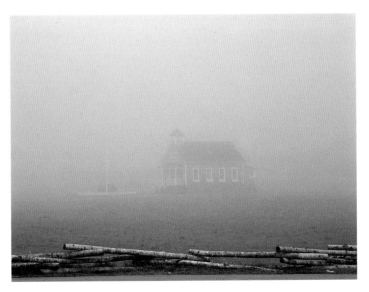

Stone Lagoon Schoolhouse from Highway 101, Humboldt County.

My suggestion is to part the thickets of argument for yourself. Visit the few old growth stands still in existence—the Rockefeller or Founder's Grove in Weott, the now-famous Headwaters Forest in Fortuna, the Lady Bird Johnson Grove north in Redwood National Park, Stout Grove in Jedediah Smith Redwoods State Park. Tramp beneath the trees, mull over what price, if any, could be attached to such a place. And, too, stop enroute at Pacific Lumber's mill in the company town of Scotia for a free, self-guided tour. What you'll find is guaranteed to dazzle: the hypnotic clang of industry— bandsaws of Bunyonesque proportion, surely a woodshop teacher's vision of heaven. I have close friends, travelers of the green byways, who quietly confess to the irresistible lure of this rough ballet between man and machine as timber makes the largely automated journey from log to dimensional lumber.

Only after visiting both places did I fully recognize that the answer is not so easy, not so readily riven between good and bad. Loggers who love the woods, environmentalists who fall under the spell of the machinery that processes harvested timber—it all reminds me of a tree itself. Few stand perfectly perpendicular to the earth. Most lean in a number of directions before reaching the top.

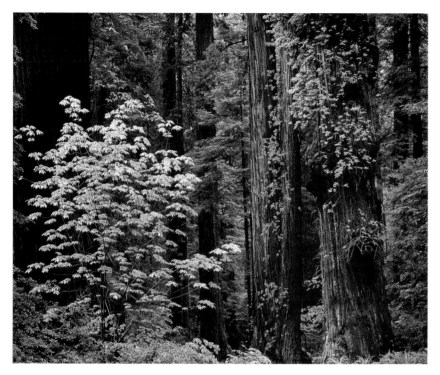

Big-leaf maples and coast redwoods in Pioneer Grove, Avenue of the Giants, Humboldt Redwoods State Park.

The debate over the disposition of northern California's coastal old growth could rage on and on—and probably will. Unfortunately, time is a commodity as valuable as redwood and in the case of the virgin stands, we are running out of both. The last groves have all but been eliminated from Mendocino County, a fact that signals more than the death of a few trees. The planet becomes a smaller place. These fragile ecosystems are as hallowed, as rare as anything found in a museum. And it would be a terrible shame if a museum becomes the last refuge of fauna such as the spotted owl, marbled murrelet, and red-legged frog.

At the same time, we use and demand lumber. Mills like the one in Scotia feed our needs.

Not so far from Scotia, a different sort of timber company harvests a small, seventy-five acre plot of timberland above the town of Blue Lake. Instead of selecting the larger trees and eschewing the smallest, this particular outfit culls only the least valuable timber, the scraggy and weak. While the strategy flies in the face of typical logging practices, it has paid handsome financial returns for the company. And, rather than a "stump farm," the forest continues largely intact, enabling the most genetically fit trees to reach their full potential. Of course, this doesn't answer the question of the dwindling old growth forests, but at least it's an intelligent start with the rest of the woods.

THE FAR NORTH

The uppermost stretch of coastal California—above Eureka and the college town of Arcata, past McKinleyville and the fishing village of Trinidad—revealed itself to me like an untold secret. I knew something existed up there, had seen the expanse of green on the map, an area of few towns and even fewer roads. I'd heard there was a maximum security prison somewhere in the area with the impossibly romantic name of Pelican Bay, although visiting the place didn't really figure into my plans. Redwood National Park sounded like a much better destination, even if its particular wonders remained a mystery to me. Mostly, I suspected the far north existed to hold up the bottom part of Oregon.

My discovery of the region began within the gunwales of a canoe, on Stone Lagoon, one of the chain of fresh-water lagoons that string out along the coast some twenty miles above Patrick's Point in northern Humboldt County. The fellow at the shop in Eureka where I purchased the craft suggested the destination, the Eel River in my neck of the woods too shallow to float a boat at that time of summer. With canoe in tow, I headed north.

Highway 101, after it escapes Eureka, more closely resembles what it once was—a nineteenth-century wagon trail that tracked north to Crescent City. Today, it's still the only overland connection between both towns. Beyond

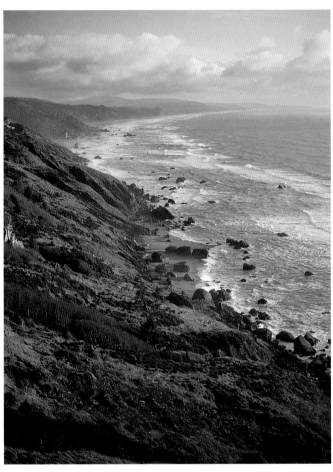

View south from Split Rock, Redwood National Park, Del Norte County.

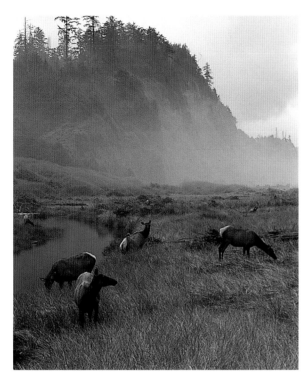

Roosevelt elk graze near Gold Bluffs in Prairie Creek Redwoods State Park, Humboldt County.

McKinleyville, 101 borders the Pacific, offering an infinite western horizon of ocean and sky. The seastacks in the surf of Moonstone Beach seem snatched from the landscape of Pacific Northwestern Oregon and Washington, and in many ways, the far north of California, from Trinidad on up, could have been a more appropriate place to draw the state line.

As you climb the state along the coast, winters are rainier, the season lingering longer. The annual rainfall in the central Humboldt County town where I live is more than twice the total of San Francisco. Fifty miles north of here, things get positively soupy, summers characterized more by fog than sun, morning dew the order of the day all day long. As the climate changes, so does the curtain of forest. You're still in redwood country, but unlike the scrubbier tan oak understory of central Humboldt County woodlands, the ground cover here is lush ferns clumped in such perfect arrangements they could have been planted by a landscaper's hand.

Del Norte is the name of the county perched at the top of the state, of the north, a translation I gleaned from the vestiges of high school Spanish, an accurate name in terms of latitude. Up here, the balance of people to wildlife tips in favor of wildlife. The number of actual towns that amount to more than a simple crossroads can be counted on one hand. But what Del Norte might lack in human population, it more than makes up in the animal variety. Within this vast, remote corner of the state, it's not uncommon to come across herds of grazing Roosevelt elk. Birders gather in Crescent City every spring and rise at dawn to witness the wonderful spectacle of Aleutian

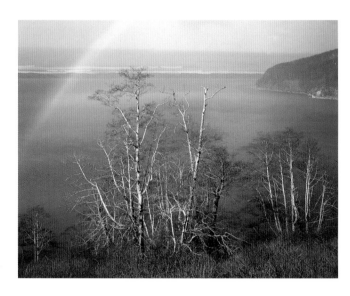

Canada geese taking wing, when the flock fills the sky like a giant white sail. In the early 1970s, the numbers of Aleutian goose dwindled to less than eight hundred. Today, because of federal protection, their numbers exceed 30,000.

Two notable rivers outlet to the sea in the far north: the Klamath, California's second largest, and the Smith, at Crescent City. One of the few rivers that still runs free to the ocean, the Smith is among the cleanest in the lower forty-eight.

I realize now how appropriate it was that my first foray into the highest rung of California was in the hollow of a canoe. That's how this place should be explored: you should venture into it. The far north reminds me of Scotland, and not only for the brooding fog or serried shoreline or emerald countryside. The main attraction is the land itself. You can park your car, walk a distance from it, and step back hundreds of years. On that afternoon in Stone Lagoon, I paddled away from the put-in spot. The wind was up, a good chop hitching across the lagoon surface, no other traffic that day, not on the road or the water. At the far end, I pulled the canoe onto the stony shore. Below, the Pacific broke against the seawall, its mist rising up to me like a salty net.

For the moment, there was only this, the ocean on one side, the lagoon on the other, the various hushings of wind and water. I watched the day draw down, happy with the knowledge that I'd finally pierced the foggy scrim of the far north. I stayed until I memorized the specifics of this cradle of water and earth, then paddled back across the lagoon, to the car and home to my woods.

–Roy Parvin

Red alders on a hillside overlooking Stone Lagoon, Humboldt Lagoons State Park.

Opposite:
Coast redwoods in Mill Creek Forest, Jedediah Smith Redwoods State Park, Del Norte County.

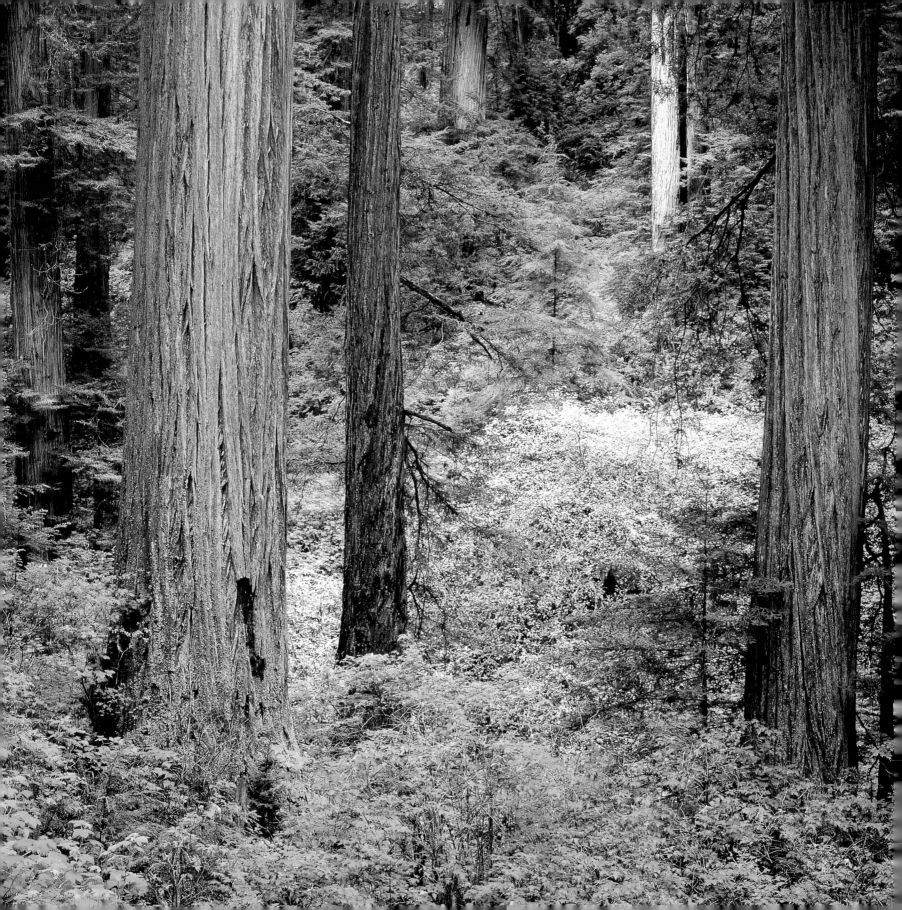

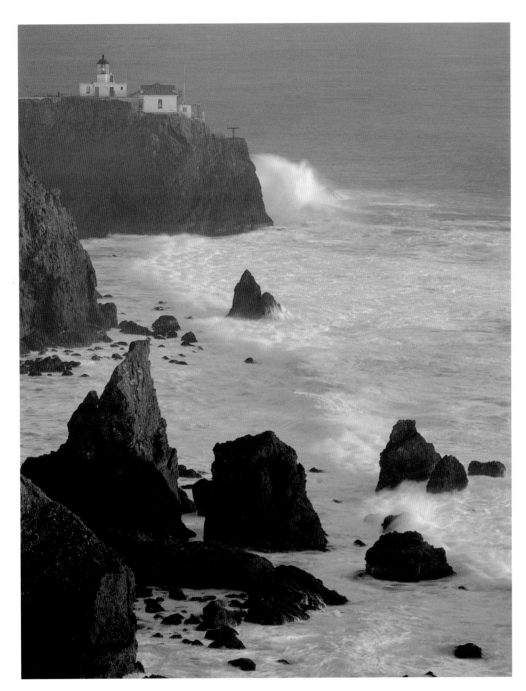

POINT BONITA LIGHTHOUSE
FROM MARIN HEADLANDS

Built in 1877, historic Point Bonita Light was the last of California's 59 lighthouses to be automated—this lonely outpost housed a lighthouse keeper until 1980. Today its computer-operated 60,000 candlepower light and fog signal warn ships away from treacherous coastal rocks.

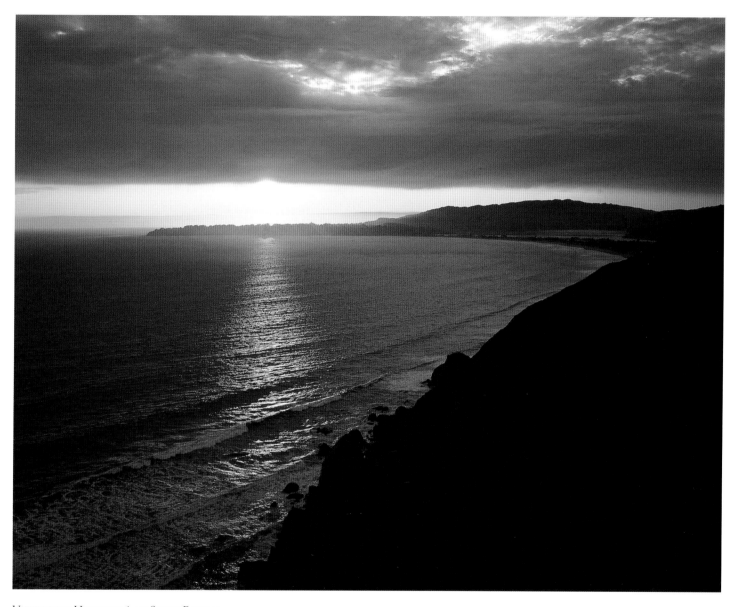

VIEW FROM HIGHWAY 1 AT STEEP RAVINE

Highway 1 offers countless ocean vistas. Rustic oceanside cabins and campsites here, part of Mount Tamalpais State Park, tempt visitors to linger after sunset.

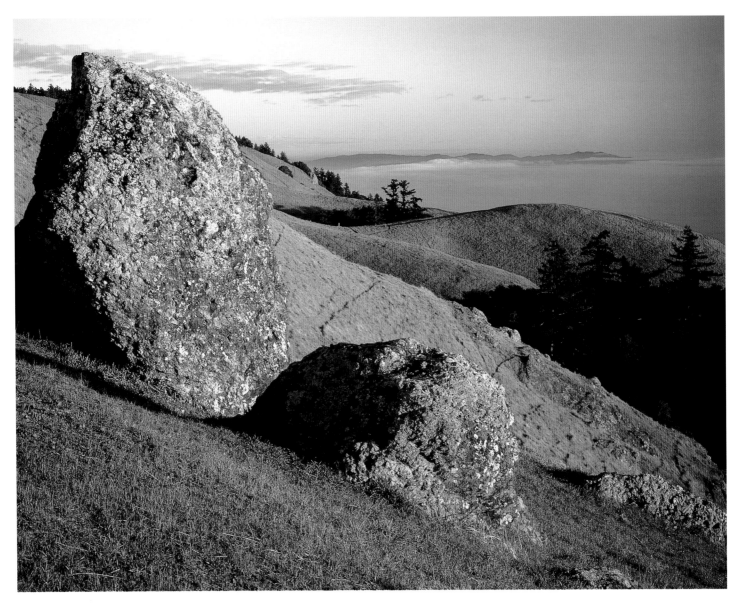

SAN PEDRO POINT FROM BOLINAS RIDGE

From the steep flank of 2,600-foot Mt. Tamalpais, the view south extends to the San Francisco Peninsula. Visitors on foot or horseback can traverse miles of trails through Mount Tamalpais State Park.

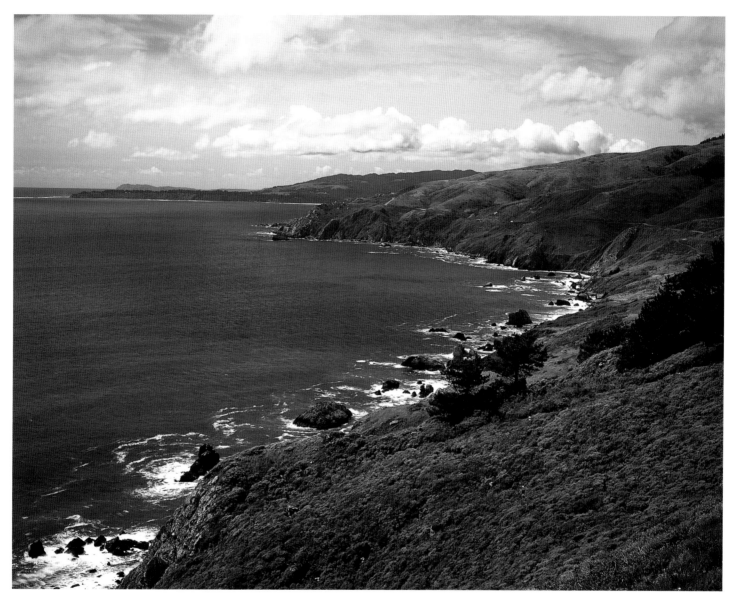

DUXBURY POINT AND POINT REYES FROM MUIR BEACH OVERLOOK

Walk out along the narrow ridge on a clear day for long views of the Marin County coast. Watch for migrating whales as they pass in the winter months.

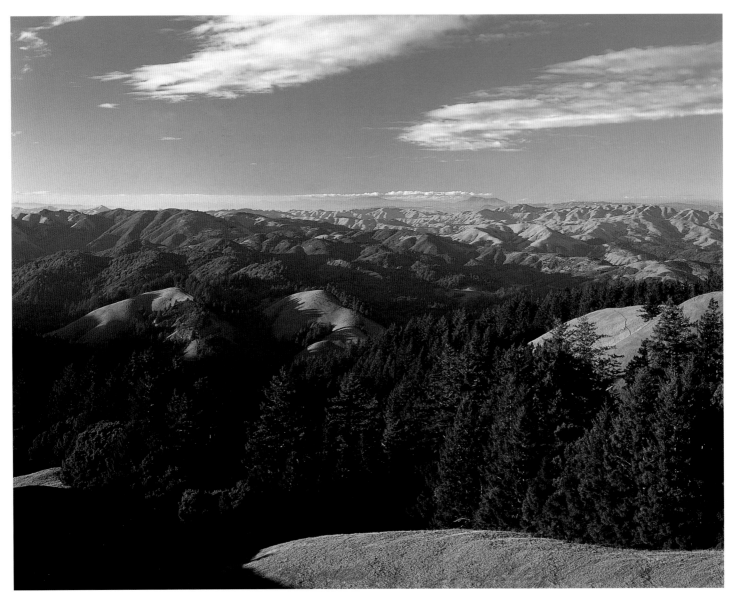

NORTH COAST RANGES FROM BOLINAS RIDGE

*Rolling hills and forests of Mount Talampais State Park undulate with brilliant green
in spring and tawny gold in the dry summer months.*

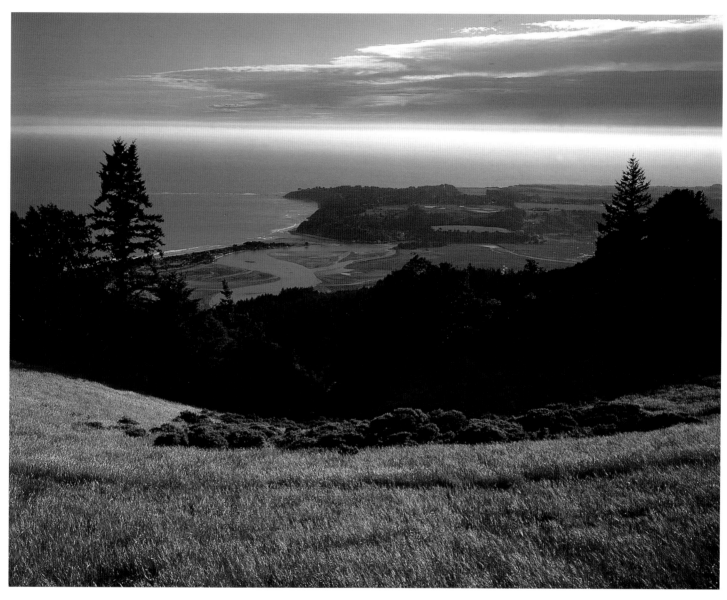

BOLINAS LAGOON AND DUXBURY POINT FROM BOLINAS RIDGE

This steep ridge offers dramatic views of Bolinas Lagoon, a rich sanctuary for nesting egrets and herons, migratory birds, and abundant wildlife.

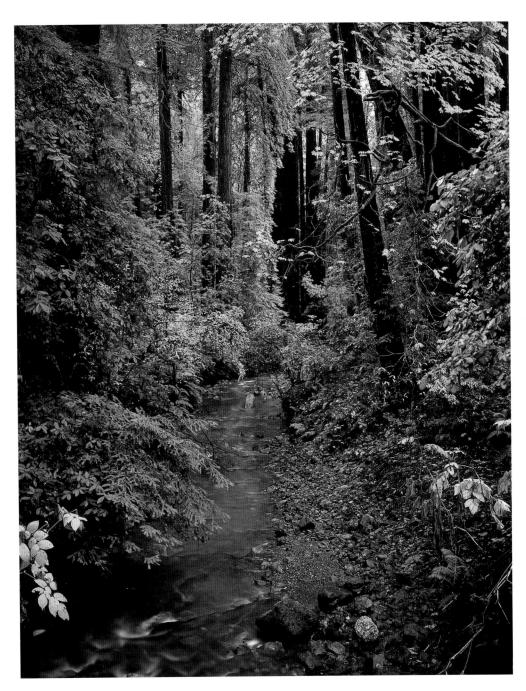

REDWOOD CREEK TRAIL

Salmon and steelhead still run in Redwood Creek, which flows from the southwest slope of Mount Tamalpais through the deep forest of Muir Woods National Monument. Named for California conservationist author and Sierra Club Founder John Muir, the Monument was established in 1908. Its grove of old-growth redwoods and sylvan trails have welcomed vsitors ever since.

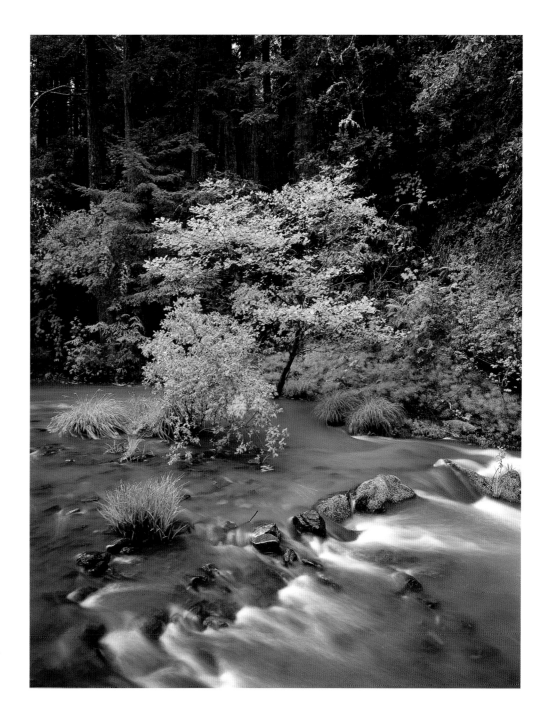

ALDERS AND COAST REDWOODS,
LAGUNITAS CREEK

Samuel P. Taylor State Park encompasses rushing creeks, redwood forests carpeted with ferns, and grassy hillsides ideal for hiking, riding, and picnics. The park includes the site of Taylorsville, a popular late nineteenth-century camping resort with its own narrow-gauge railroad.

RANCHO BAULINES, HIGHWAY 1 AT OLEMA-BOLINAS ROAD

Built directly on the San Andreas fault, this historic ranch has endured many an earthquake. This reminder of Marin County's early pioneer heritage is preserved within Golden Gate National Recreation Area.

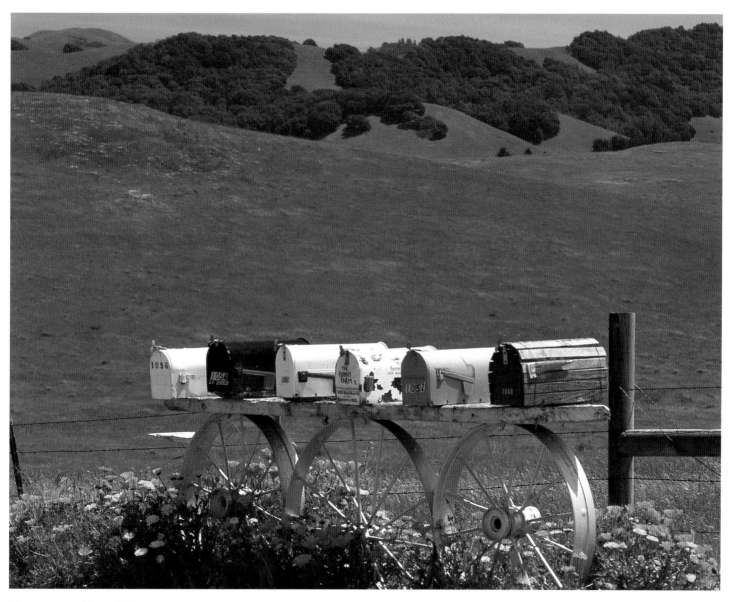

MAILBOXES IN HICKS VALLEY

*The back roads of Marin County maintain much of the region's rural roots
and country charm. Live oaks grace the ridgelines above verdant pasturelands.*

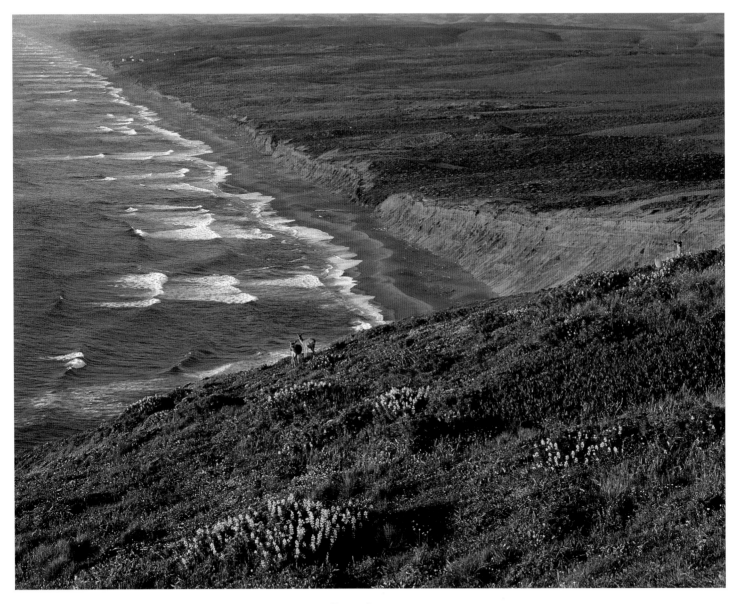

COLUMBIAN BLACK-TAILED DEER AND YELLOW BUSH LUPINE ON POINT REYES

Wave-scoured Point Reyes Beach stretches eleven miles northward from Point Reyes'
wild, windswept headland. The San Andreas Fault separates the Point Reyes
Peninsula geologically from the mainland.

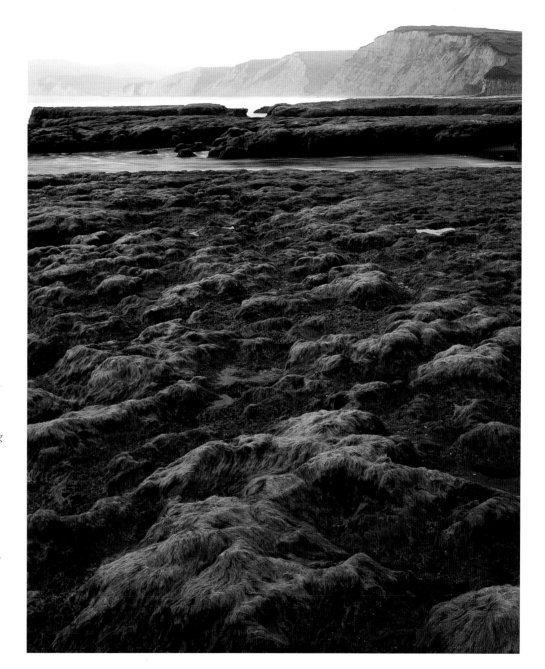

DRAKES BEACH,
POINT REYES NATIONAL SEASHORE

Minus tides expose sea grass-covered rocks at Drakes Beach, named for the English adventurer Sir Francis Drake who landed here in the summer of 1579. Drake and his crew stayed several weeks, trading for food with the Miwok people and exploring the rich inland landscapes. Although Drake named this region Nova Albion, or New England, the English never returned to settle these lands. Spanish explorer Don Sebastian Vizcaino, who spent a stormy day anchored in Drakes Bay in early January, 1603, named the headlands La Punta de Los Reyes *for the feast day of the Three Kings. The area was finally settled by Europeans after 1769 when Spanish overland explorers stumbled upon San Francisco Bay and discovered the foggy, obscure entrance mariners had missed which we now call The Golden Gate.*

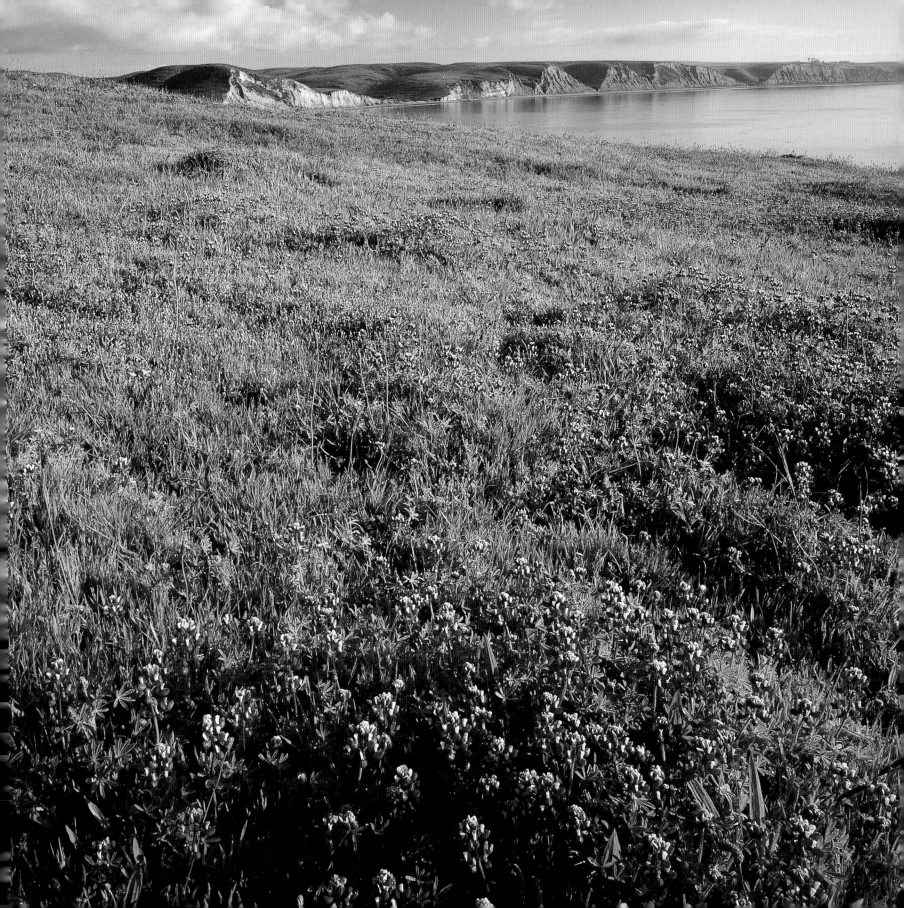

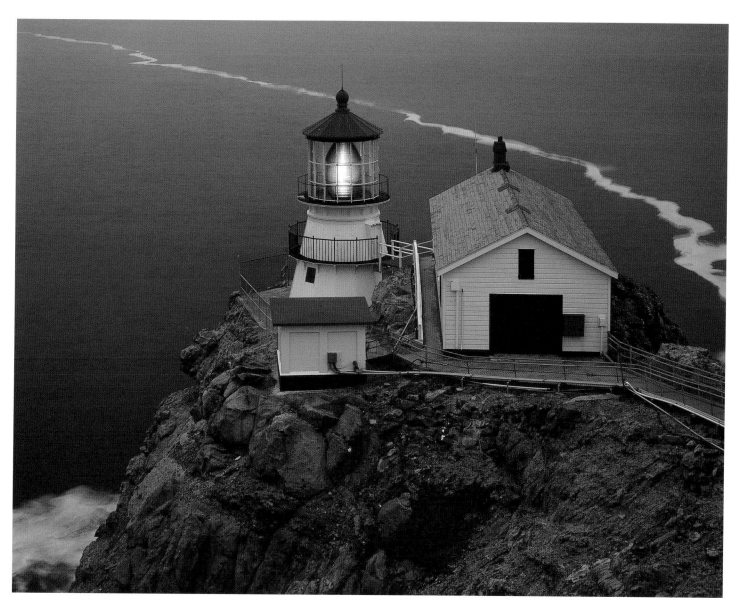

POINT REYES LIGHTHOUSE

Three hundred steps lead down to the Point Reyes Light, arguably the foggiest, windiest spot on the California Coast. Watch annual migrations of gray whales from the headland above, or scan the rocks below for common murres, harbor seals, and sea lions.

LUPINE ON POINT REYES,
OVERLOOKING DRAKES BAY

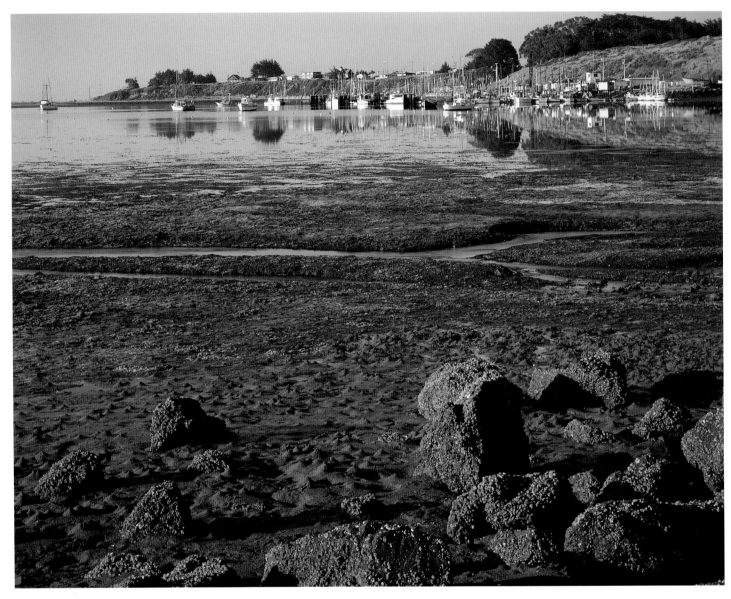

LOW TIDE AT BODEGA BAY

The town of Bodega Bay—originally established as a commercial fishing port in the Bay's protected anchorage—retains its salty charm with ocean-view inns, galleries, and fresh seafood eateries. Alfred Hitchcock chose Bodega Bay as the setting for his classic film, "The Birds."

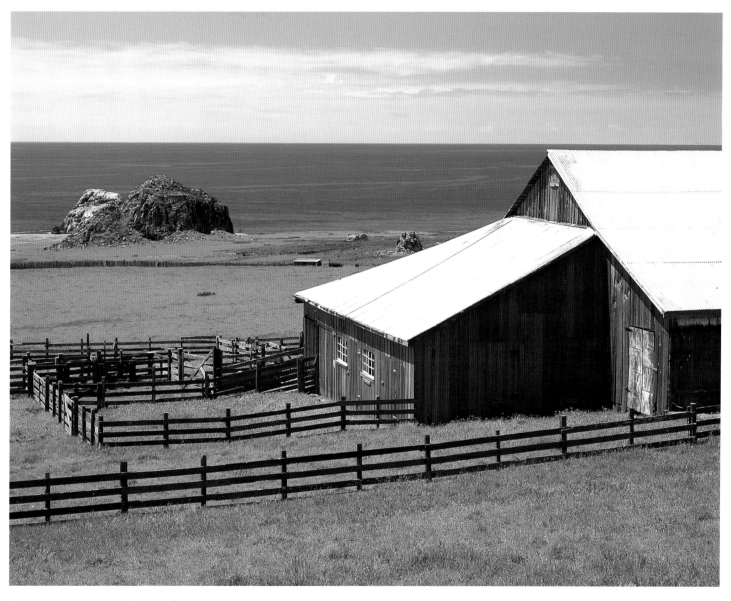

RANCH SOUTH OF THE RUSSIAN RIVER, NEAR GULL ROCK

Along Sonoma Coast State Beach rolling farmlands meet rocky headlands in a scenic mixture of pastoral and coastal landscapes.

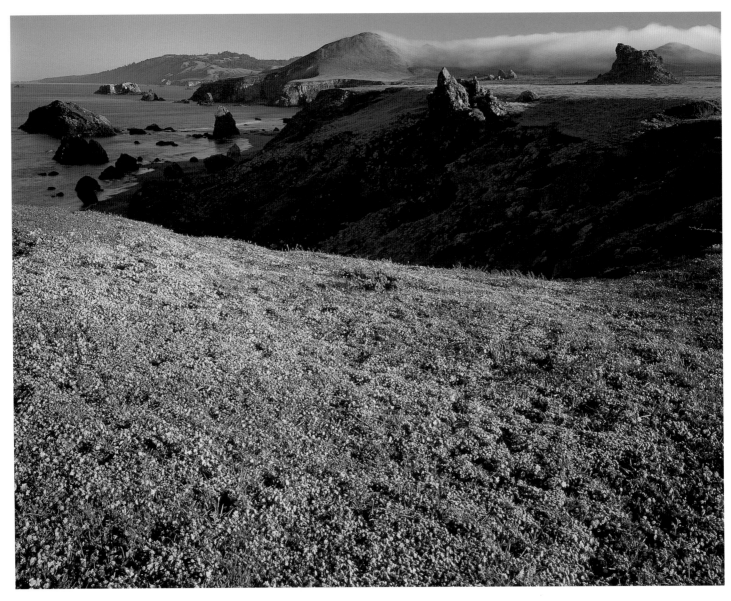

PEAKED HILL AND GULL ROCK, SONOMA COAST STATE BEACH

Marine terraces—old beaches raised above sea level by uplift and carved by surf—create habitat for early April wildflowers, such as these coast goldfields. Sea stacks and sloping headlands are common along Sonoma Coast State Beach.

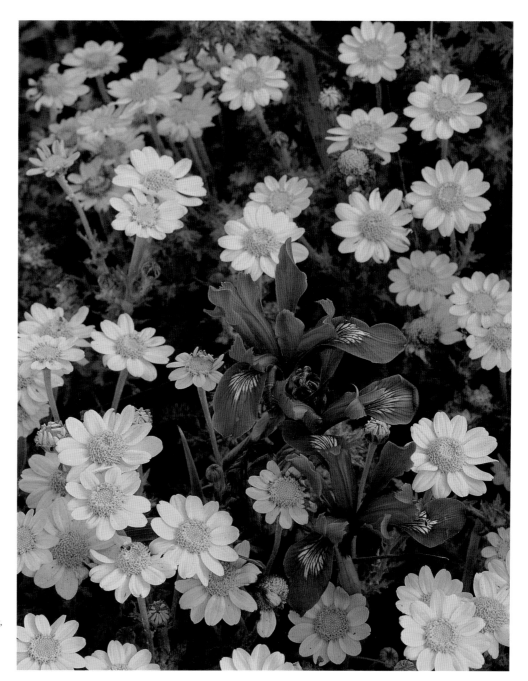

DOUGLAS IRIS AND WOOLLY LASTHENIA

One of the most common wildflowers along the North Coast, Douglas iris form large colonies in open coastal hills. Native people used iris leaf fibers to make strong pliable ropes for fishing nets and hunting snares. Larry photographed this pair of iris blossoms, surrounded by bright yellow woolly lasthenia, in late April at Gualala Point Regional Park.

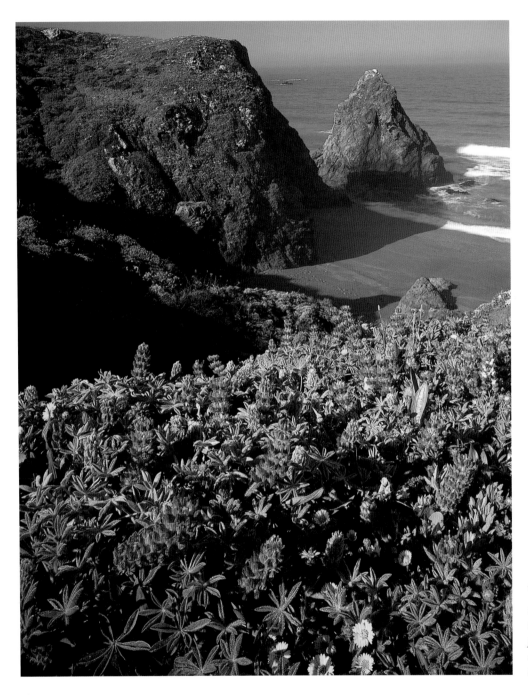

WILDFLOWERS ABOVE SHELL BEACH

*Chick lupine and common madia bloom
in spring at Shell Beach—one of many
pocket beaches separated by rocky headlands
along Sonoma Coast State Beach, south of
the Russian River.*

SHELL BEACH,
SONOMA COAST STATE BEACH

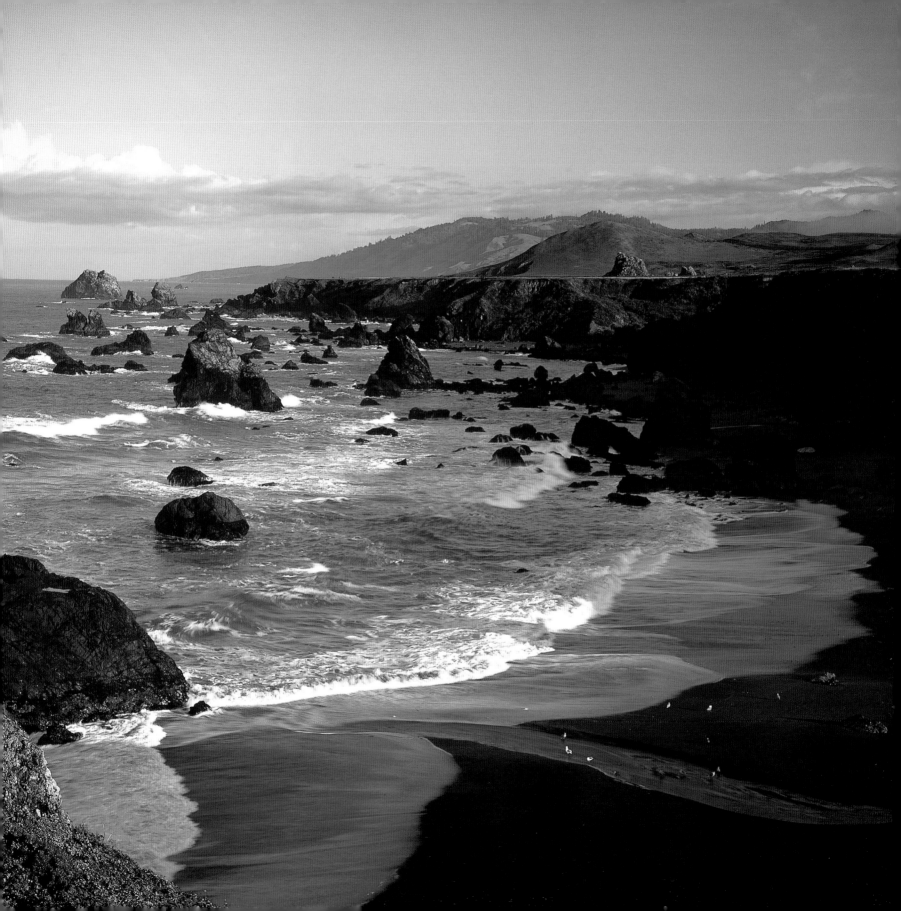

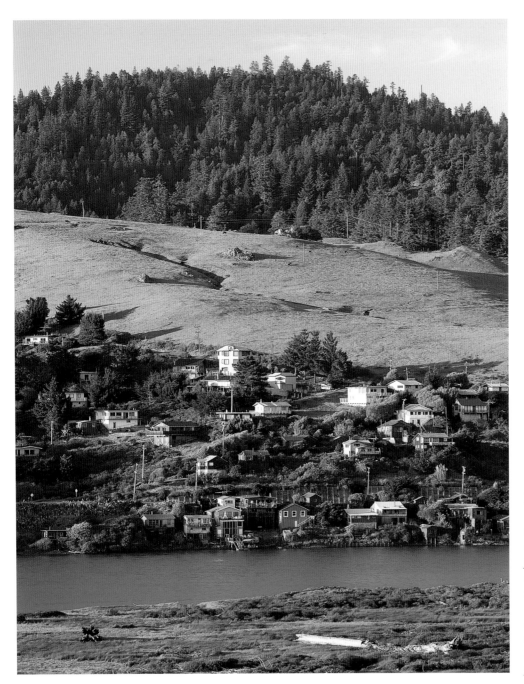

JENNER AND THE RUSSIAN RIVER

The Russian River, named for early nineteenth century explorers and trappers who hunted sea otter in this region, flows from the east to meet the Pacific Ocean at Jenner. A collection of bungalows on the hillside overlooks the wide, peaceful lagoon. The usually placid lower Russian River is known for severe floods during winter rainstorms. Some riverside buildings are built on stilts to protect them from rising flood waters.

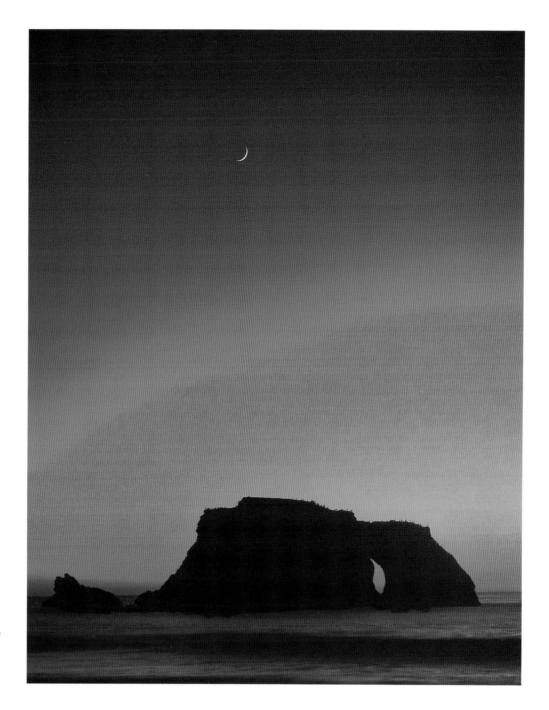

ARCH ROCK FROM BLIND BEACH

Sunset silhouettes the distinctive shape of Arch Rock, photographed from the bottom of the steep cliff trail to Blind Beach, Sonoma Coast State Beach. The rock provides a protected rookery for sea birds.

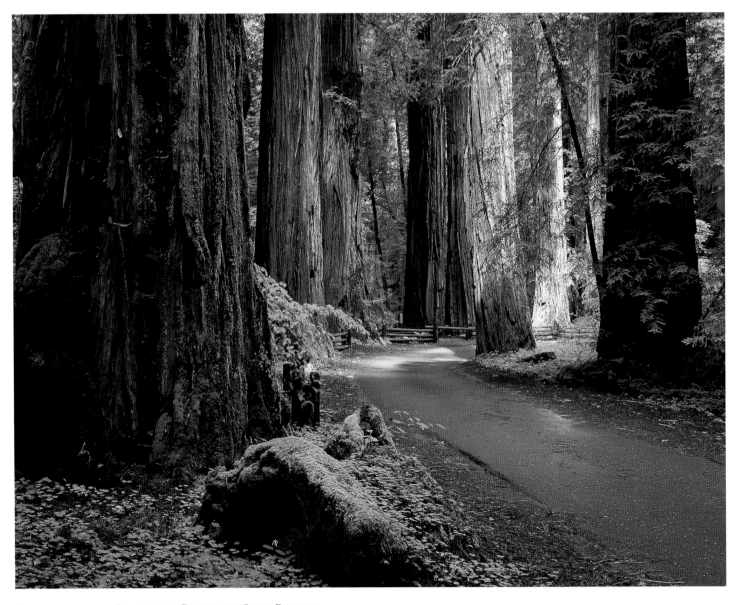

COAST REDWOODS, ARMSTRONG REDWOODS STATE RESERVE

A five-hundred acre grove of ancient coast redwoods north of Guerneville invites a walk through remnant stands of primeval forest that once stretched across the North Coast. Colonel James Armstrong, a lumberman, preserved the grove in the 1870s.

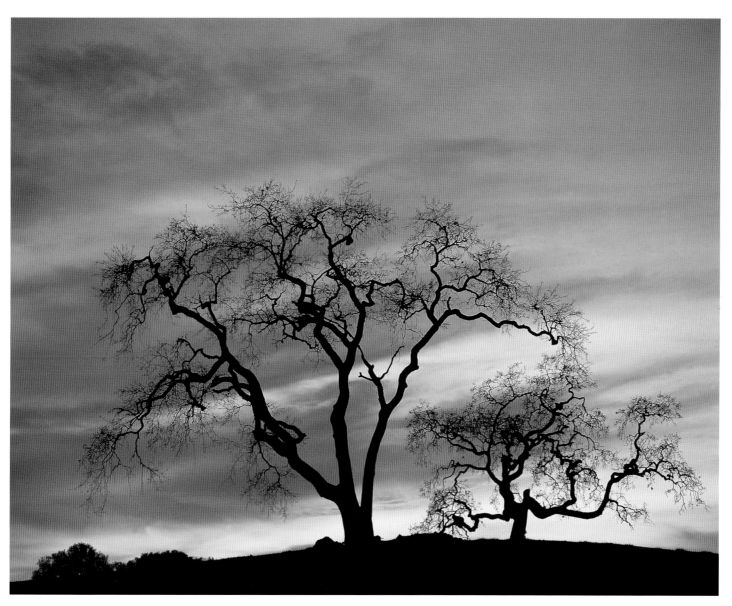

Dry Creek Valley

A January sunset silhouettes winter-bare valley oaks on a ridge of the North Coast ranges, west of Highway 101 near Healdsburg.

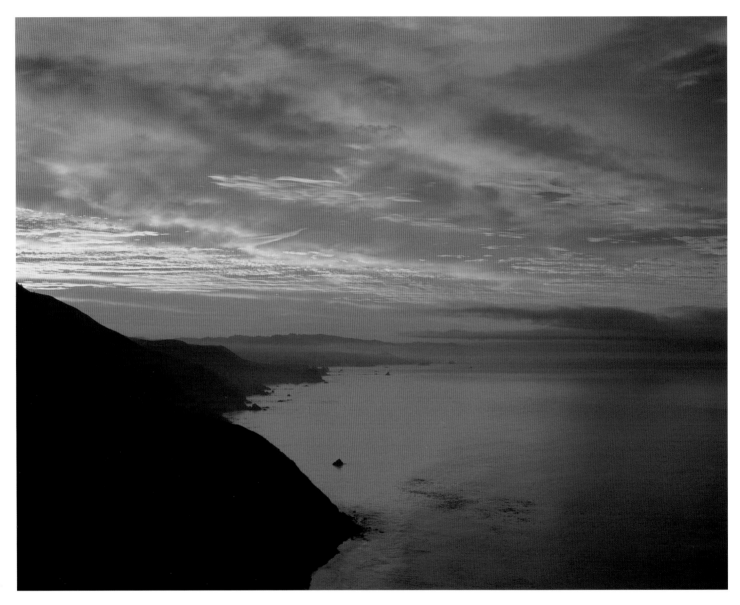

RED SKY AT MORNING

From a headland north of the Russian River, the vivid colors of sunrise predict a coming winter storm. Here Highway 1 rises six hundred feet above the rocky coastline, affording views of the endless sea stacks to the south.

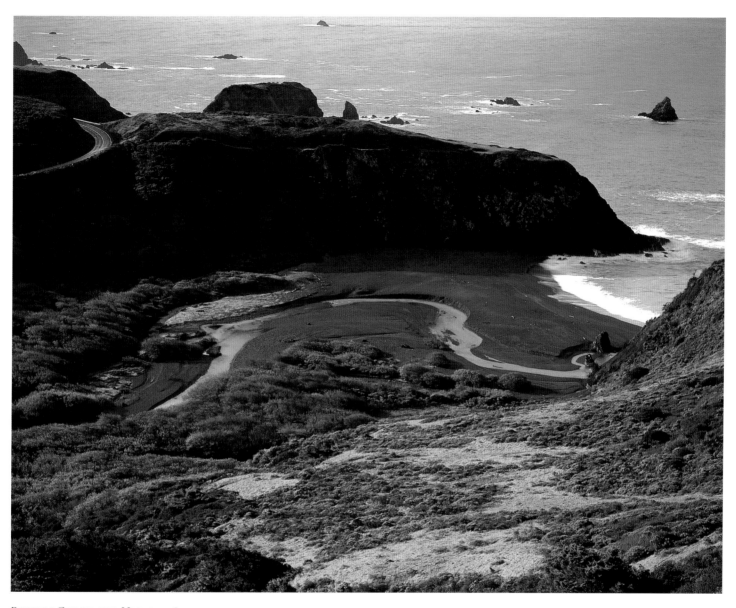

RUSSIAN GULCH AND HIGHWAY 1

Highway 1 winds its way through headlands and dizzying curves along the Sonoma County coast. This beach was named for Russian colonists who kept a vineyard on a nearby hillside.

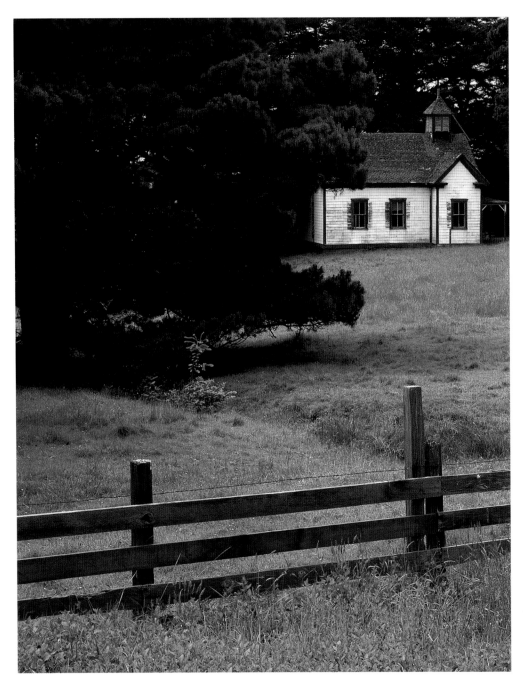

STEWARTS POINT SCHOOL

A weathered schoolhouse speaks of early days when the tiny town of Stewarts Point thrived as a lumber port. Fences, gates, and buildings made of local redwood weather to a silvery gray.

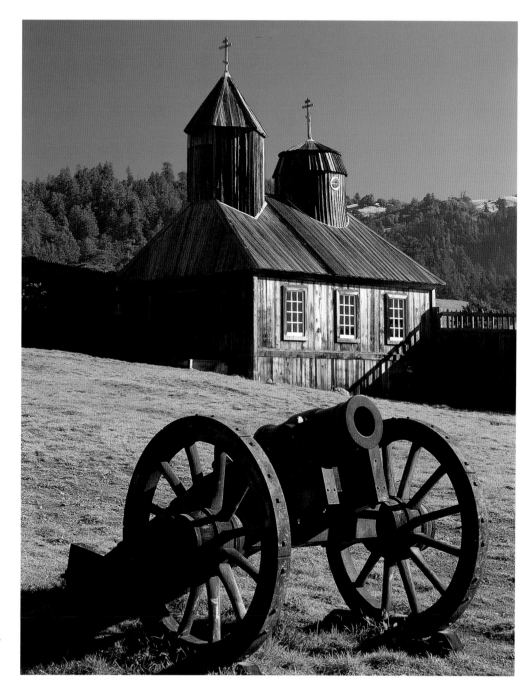

FORT ROSS STATE HISTORIC PARK

Russian fur hunters built this wooden fort in 1812 to protect farming and hunting interests and to secure the possibility of a Russian colony here. The chapel at Fort Ross is a reconstruction of the original wooden Russian Orthodox chapel built about 1824. The Russians left in 1841, and the site was ranched until it became a California State historic site in 1906. Today visitors can stroll the meticulously reconstructed historic stockade and imagine this remote Russian outpost as it was nearly two centuries ago.

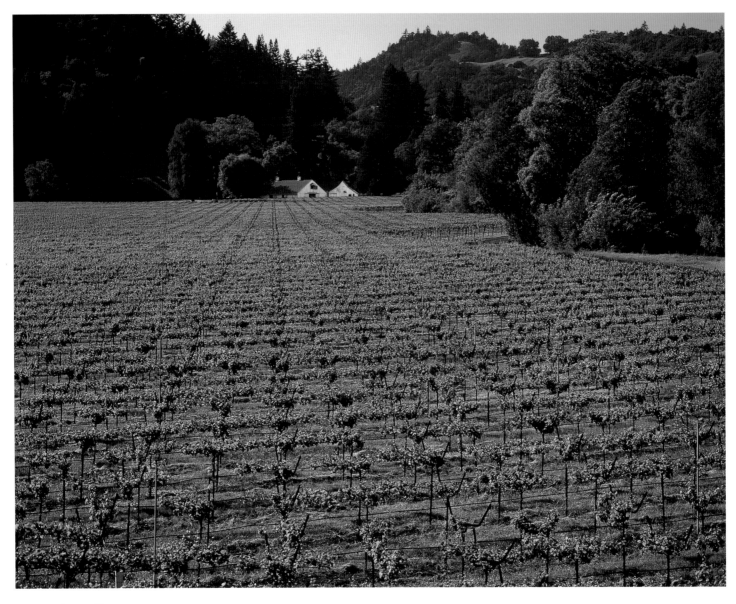

PORTER CREEK VINEYARDS

In the emerging wine-growing region along West Side Road in the Russian River Valley,
grapes grow up to the edge of mature second-growth redwood groves.

WESTERN RHODODENDRON AND COAST REDWOODS

In late spring and early summer, saucer-sized blooms in hot pink and salmon entice flower-lovers into Kruse Rhododendron State Reserve. A fire in the second-growth redwood forest here provided ample sunshine for the rhododedrons, an example of natural plant succession. Rancher Edward Kruse gave this 317-acre parcel to the State of California in 1933. Easy hiking trails through redwoods and oaks attract hikers year-round.

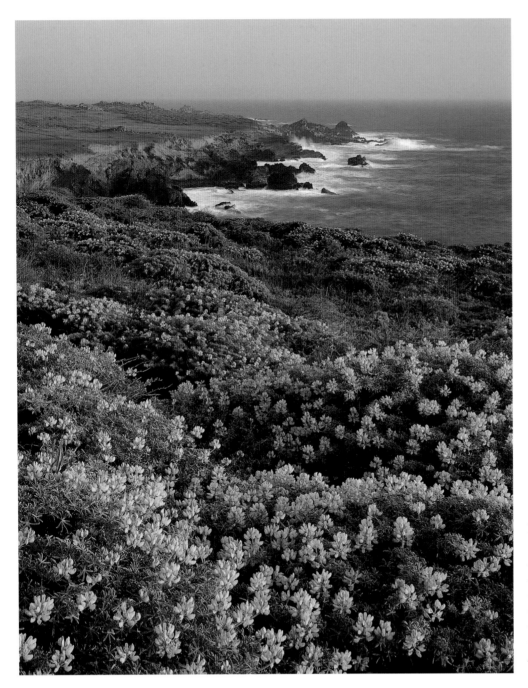

HEADLANDS AT STUMP BEACH COVE

Yellow bush lupine blooms above rocky shorelines of a wave-pounded cove in Salt Point State Park. Clear days offer spectacular views in any direction; foggy days envelop visitors with the song of the surf. Hikers can climb to a pygmy forest where Bishop pine, redwood, and cypress grow peculiarly stunted from the whitish, nutrient-starved soil.

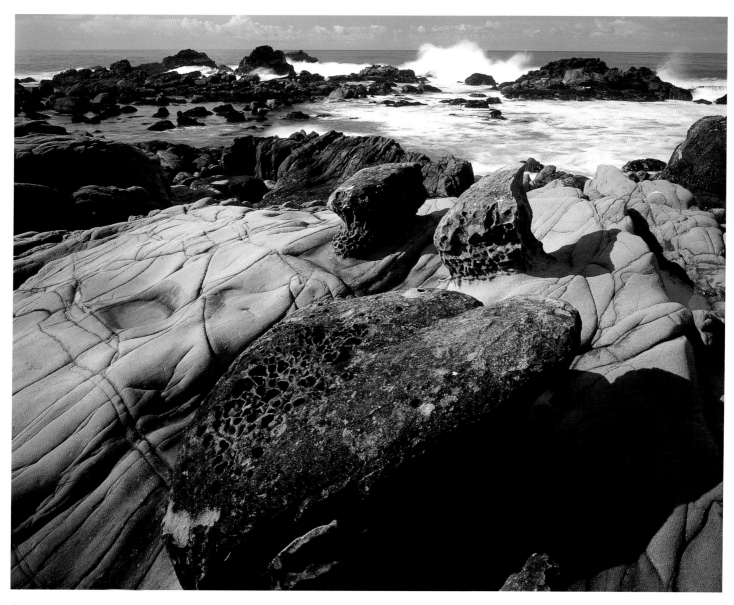

SALT POINT

The Kashaya Pomo maintained fishing villages here, harvested salt from the rocks of the intertidal zone, and plucked urchins and abalone from these waters. Today's tidepoolers and scuba divers enjoy the intertidal environment on calm surf days.

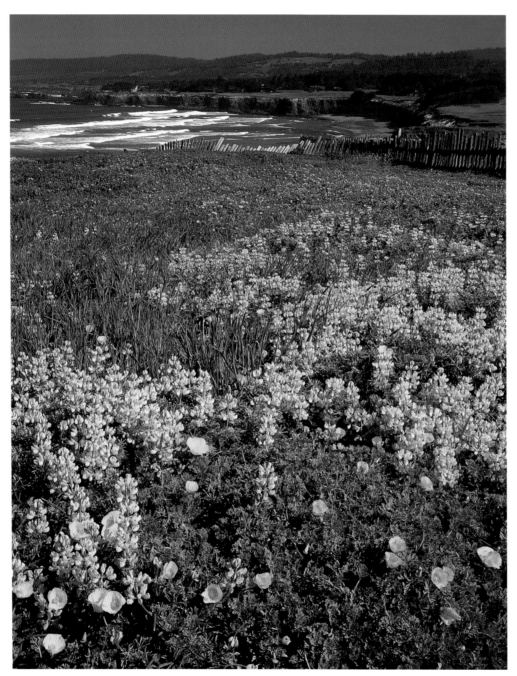

BLACK POINT, SEA RANCH

California poppies and lupines bloom along the coastal access at Black Point, one of five trails established by the California Coastal Commission that traverse ten miles of private development along the coast at Sea Ranch. Amid the trees and ridges private roads lead to marvelously designed vacation homes—some available for rental for those wishing to linger in this remote coastal getaway.

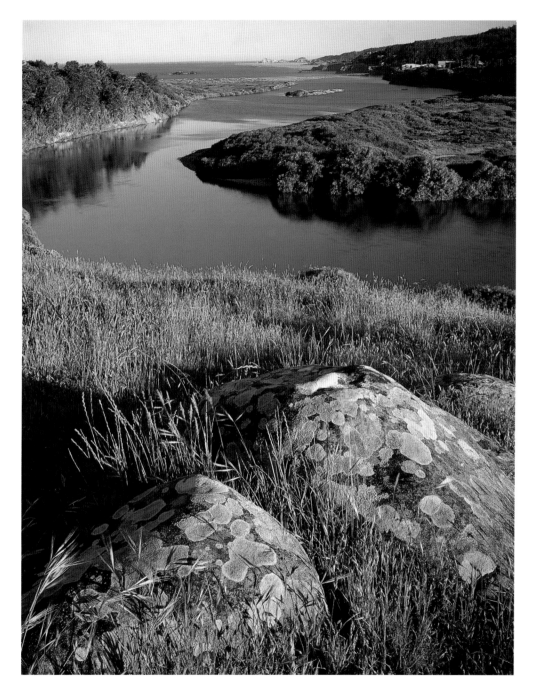

GUALALA RIVER

Gualala (pronounced Wallala) is a Spanish version of the Pomo word for this place, meaning "where the waters meet." Here the Gualala River meets the sea, forming an estuary habitat for sea life as well as shore birds. Watch for osprey and heron hunting for seafood meals within view of the town of Gualala.

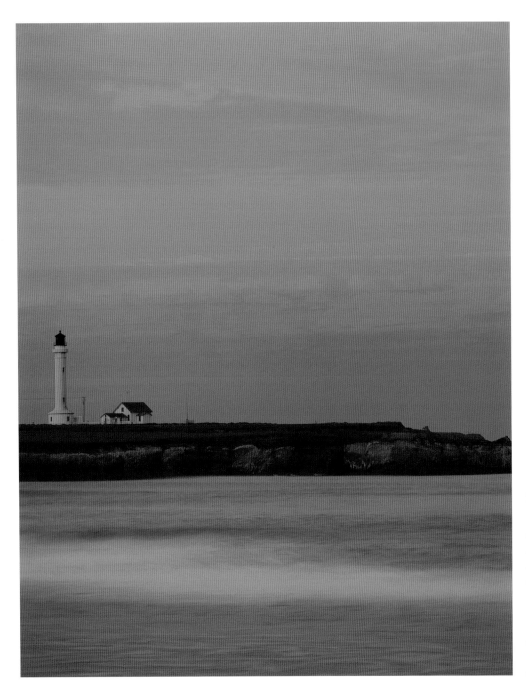

POINT ARENA LIGHTHOUSE

Viewed from Manchester State Beach at sunrise, the regal light at Point Arena stands sentinel on its rocky spur of the Mendocino County coastline. Severely damaged in the infamous earthquake of 1906, this historic station has been reconstructed to its classic 115-foot glory. Visitors may tour the lighthouse and adjacent museum of nautical treasures, including the huge Fresnel lens retired by automation of the lighthouse in 1977.

BOWLING BALL BEACH,
SCHOONER GULCH STATE BEACH

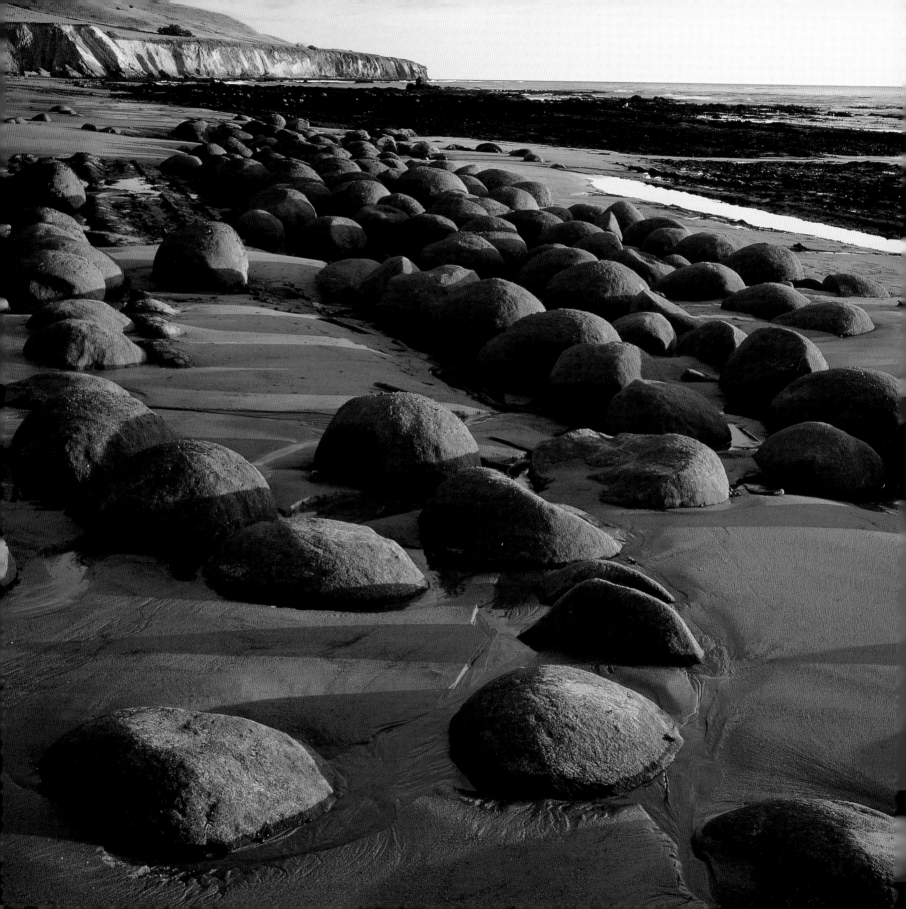

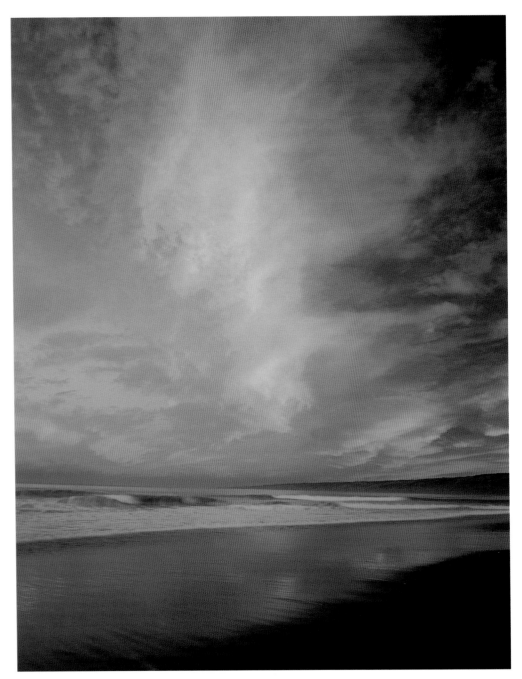

SUNRISE CLOUDS AT MANCHESTER
STATE BEACH

*Donna Ulrich has a special fondness for
Manchester State Beach. When her
grandmother was a baby, the family
returned by schooner from a trip to San
Francisco. The small boat that brought them
to shore capsized here, throwing all
occupants into the waves. When everyone
was ashore the infant was assumed
drowned, but an alert man witnessing the
accident from shore rolled the little one over
a barrel and revived her. Donna owes her
life to that fellow! On calm days, the wide
beach is a peaceful place.*

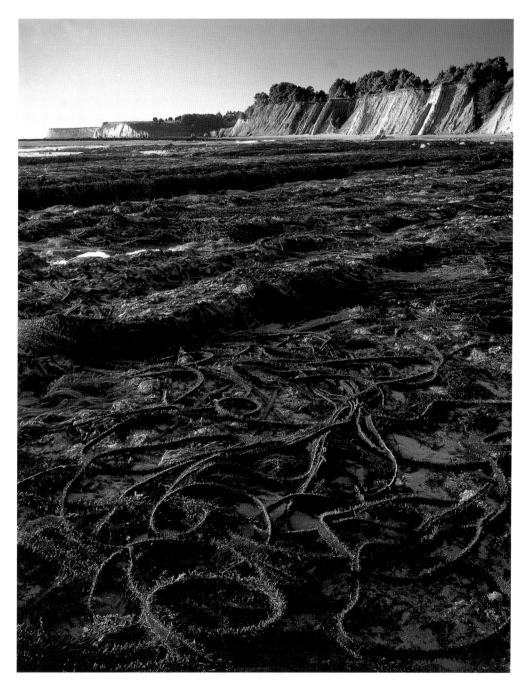

KELP AND SEAWEED AT
SCHOONER GULCH STATE BEACH

A minus tide reveals rich intertidal habitats in another view of Bowling Ball Beach's unusual rock formations. The rounded concretions erode out of the surrounding sandstone of the cliffs and fall to the beach below.

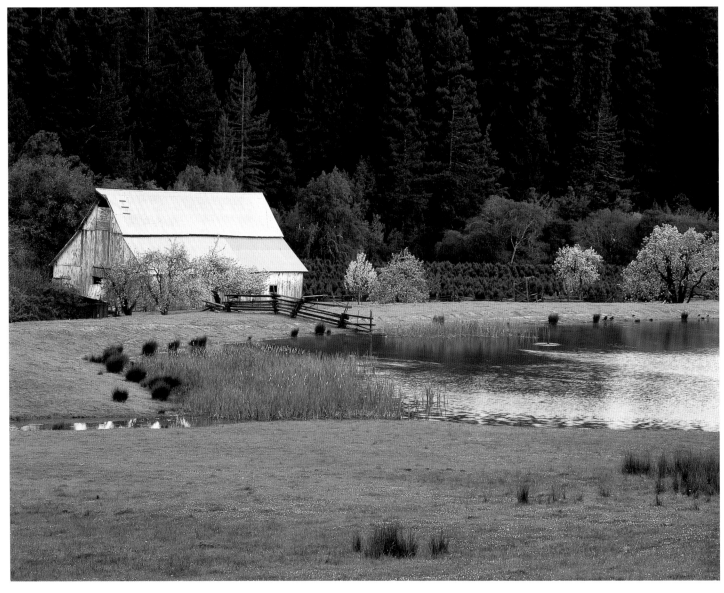

BARN IN THE NAVARRO RIVER VALLEY

Redwood forest surrounds cleared farmland a few miles north of Philo on Highway 128.

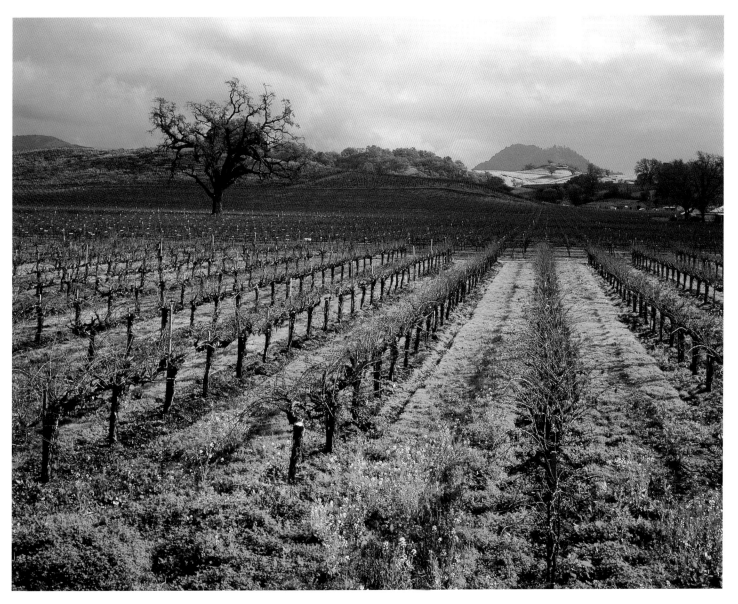

VALLEY OAKS RANCH, FETZER VINEYARDS

A winter storm has passed and mustard blooms between rows of grapes near Hopland. Wine production—and alternative retailer Real Goods Solar Living Center on Highway 101—keep this agricultural town busy.

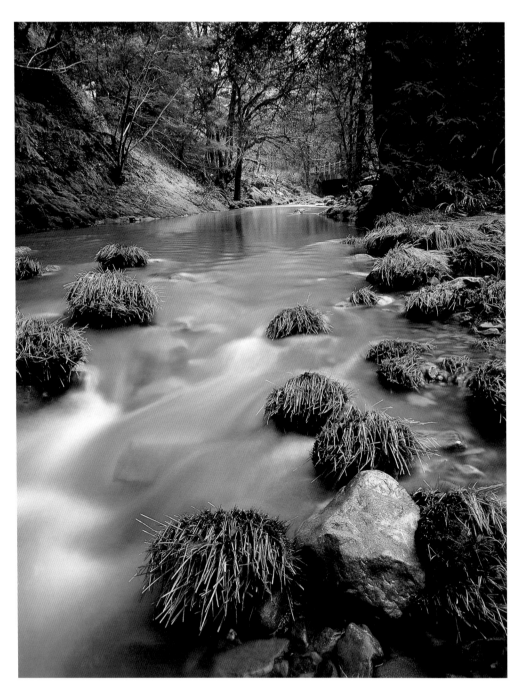

SOUTH FORK, BIG RIVER

Montgomery Woods State Reserve, east of Highway 1 along the Comptche-Ukiah Road, preserves remnants of majestic virgin redwood forests which once covered Mendocino County hillsides. Straddling the South Fork of the Big River, the park offers walking trails through several groves of huge old-growth trees. At nearby Orr Springs, a popular hot springs resort, soakers enjoy rustic baths amid the trees.

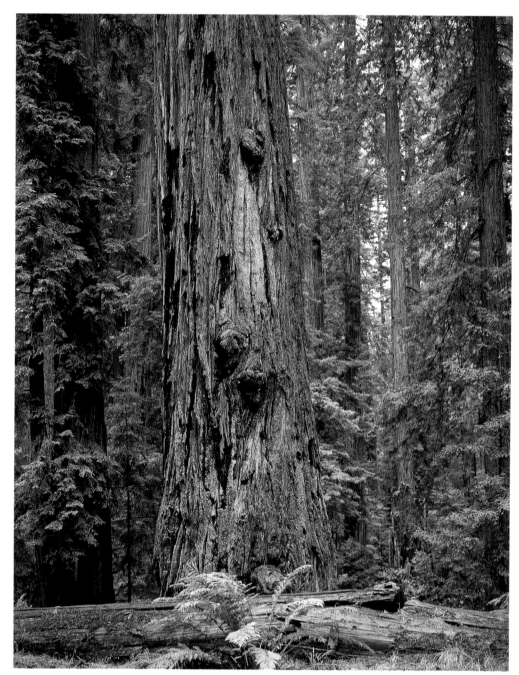

Montgomery Woods State Reserve

When Larry and Donna first photographed this huge tree in January, 1984, they noticed a rope descending the trunk. A friend at the Save-The-Redwoods League explained the mystery a few months later: an environmentally sensitive logger had climbed to the top of the tree with a 400-foot rope and dropped the entire length down the trunk. Since the rope never reached the ground, this strapping old redwood was unofficially recognized as the world's tallest tree—a local secret kept for years to help focus attention on preservation efforts at the Tall Trees Grove in Redwood National Park.

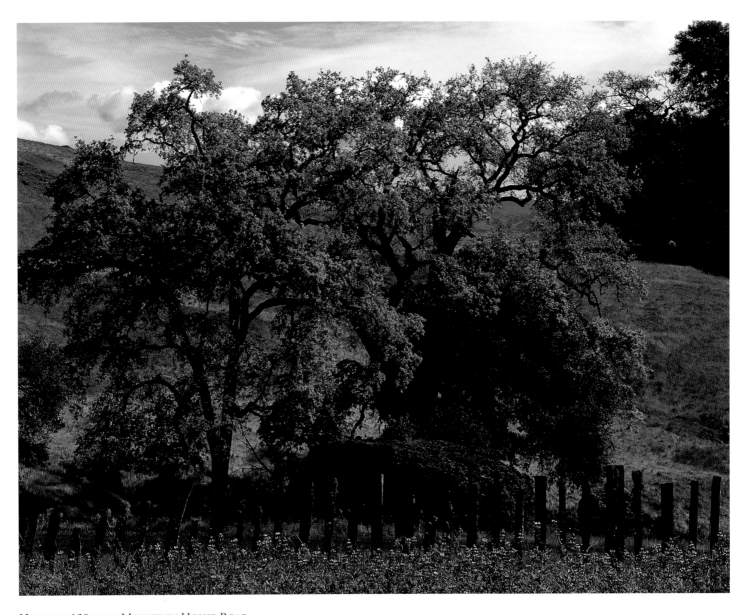

HIGHWAY 128 NEAR MOUNTAIN HOUSE ROAD

Douglas lupine and Oregon white oaks line a split redwood fence along the highway west of Cloverdale. The rolling countryside landscape makes this route one of Mendocino County's loveliest backroad drives.

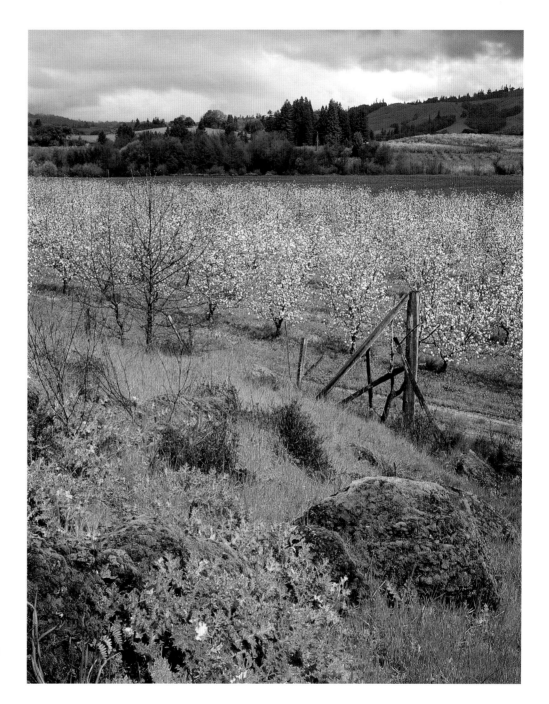

APPLE ORCHARD ALONG THE NAVARRO RIVER

Highway 128 traverses the Anderson Valley, a bucolic landscape of vineyards and orchards with sheep-dotted fields. Visitors taking a leisurely drive will discover ideal picnic spots, boutique wineries and microbreweries, fruit stands, and the small-town delights of Yorkville, Boonville, and Philo.

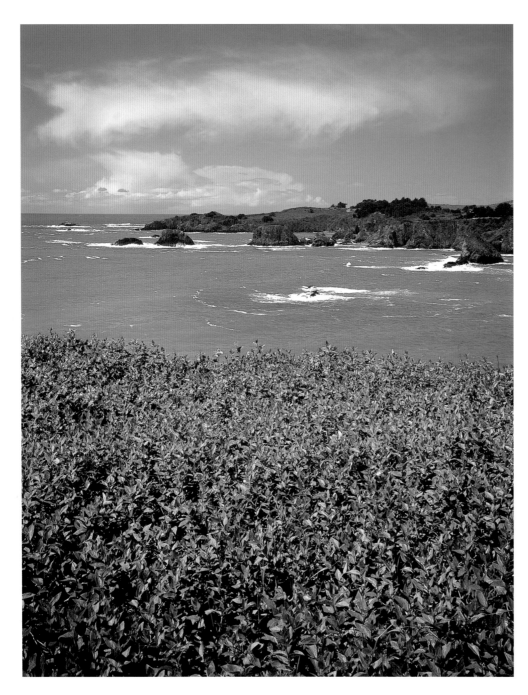

CUFFEYS COVE

Vinca blooms on a headland above Greenwood State Beach. Highway 1 meanders northward through the seaside villages of Elk, Albion, and Little River, passing spectacular views of the wild, rocky Mendocino Coast.

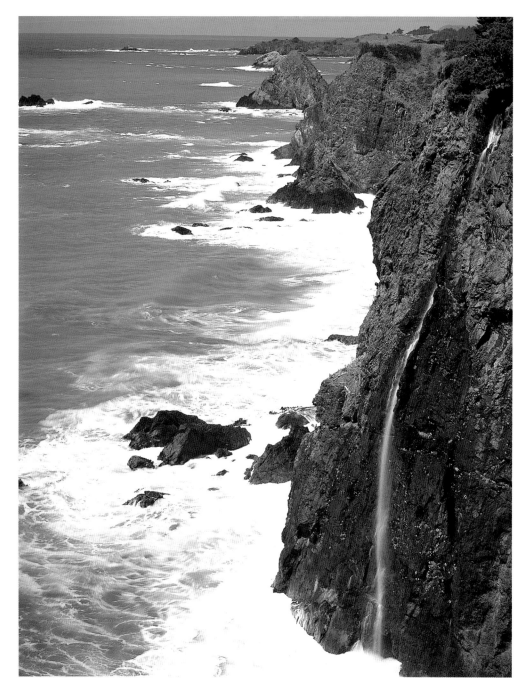

WINTER WATERFALL

Forested headlands topped with green foliage south of Elk drop abruptly into steep cliffsides, creating ephemeral waterfalls as winter run-off cascades to the sea.

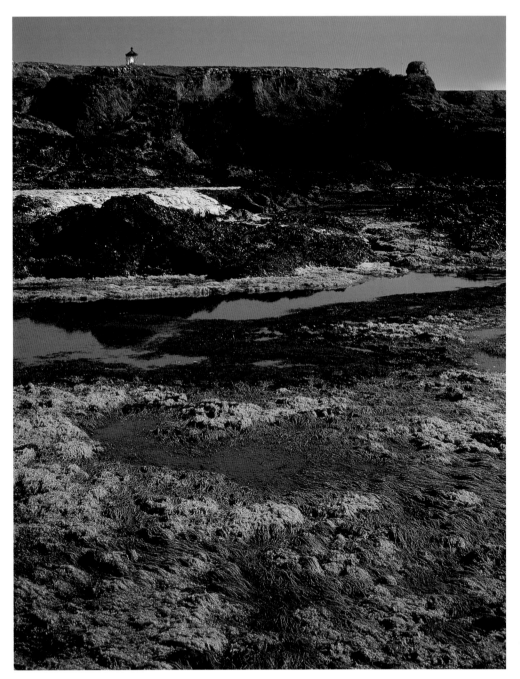

POINT CABRILLO LIGHT STATION

At low tide, marine algae paints brilliant color on the rocks of Point Cabrillo north of Mendocino. Sailing ships plied this coast in early lumber-boom days, dependent on lighthouses to light the way through the fog. Skippers with nerves of steel employed small two-masted vessels, called doghole schooners, to negotiate exposed rocky anchorages—the nimble ships could sail straight in toward the rocks and then turn abruptly like a dog lying down into a shallow hole. Open skiffs transferred cargo through the waves from shore to schooners. Today the headlands provide an excellent vantage to watch for gray whales migrating south in winter and north in spring.

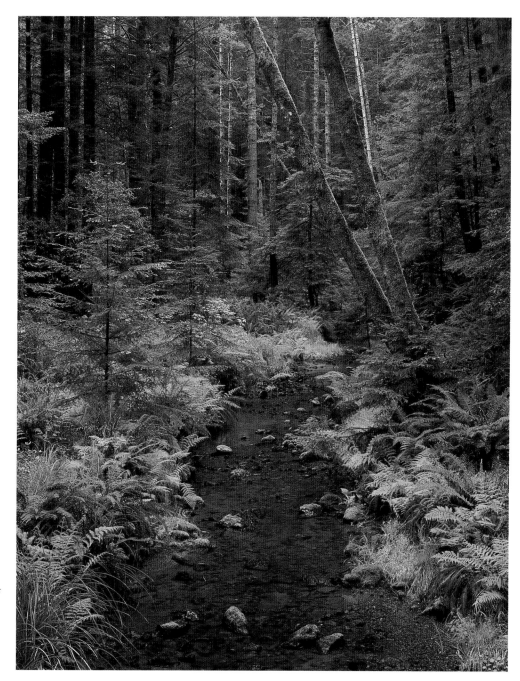

FERN CANYON

Van Damme State Park stretches inland along the Little River from a sheltered cove and pocket beach at Highway 1. A luxurious trail into Fern Canyon enters immediately into a moist, verdant world of moss-covered red alders, coast redwoods, and their rich understory of ferns and berry bushes. Hikers can traverse wooden bridges across the river.

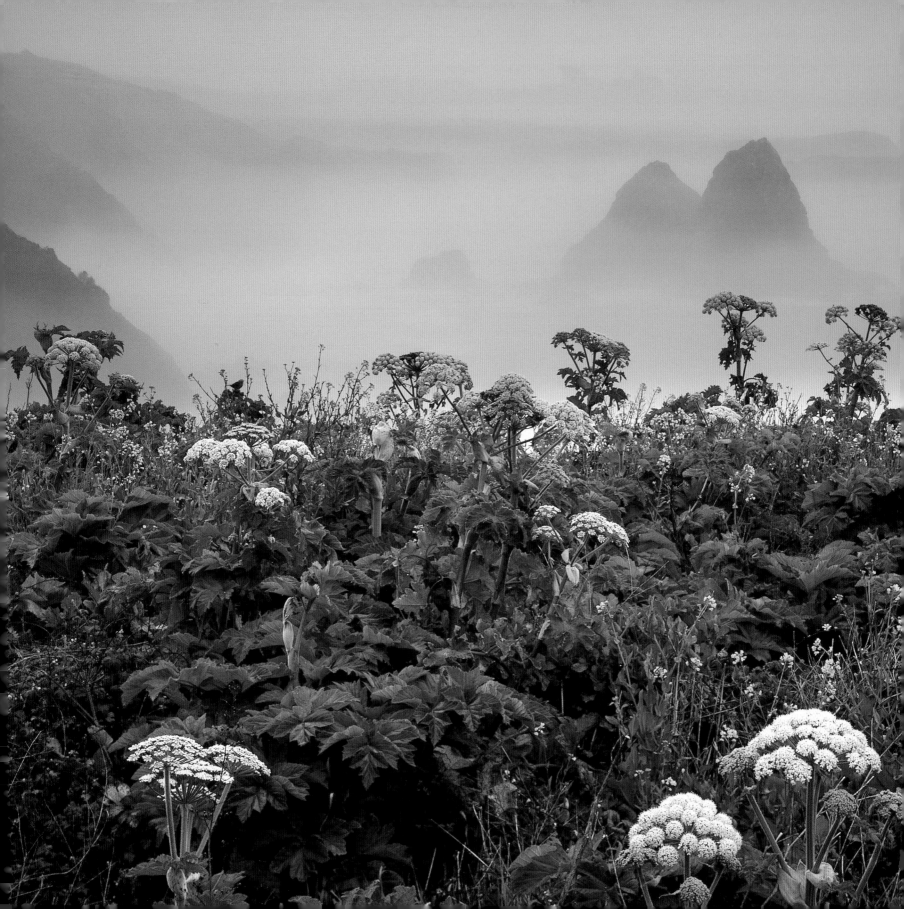

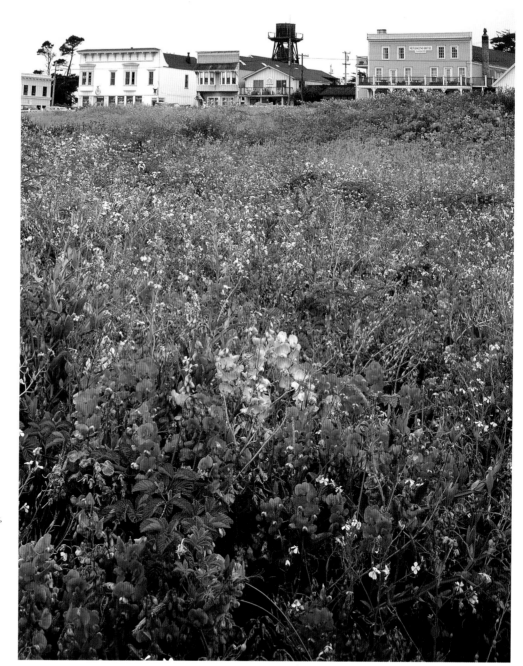

MENDOCINO

*Sweet peas bloom across from the shops
and water towers of Mendocino. Although
it resembles a New England whaling village,
the town was founded in 1852 to house a
sawmill for the growing redwood lumber
industry needed to build San Francisco.
Now the town flourishes as an artist colony
and weekend getaway resort, offering
galleries, restaurants, and charming inns.
The picturesque village is surrounded on
three sides by the greenbelt of Mendocino
Headlands State Park.*

COW PARSNIP ABOVE
CUFFEYS COVE, NEAR ELK

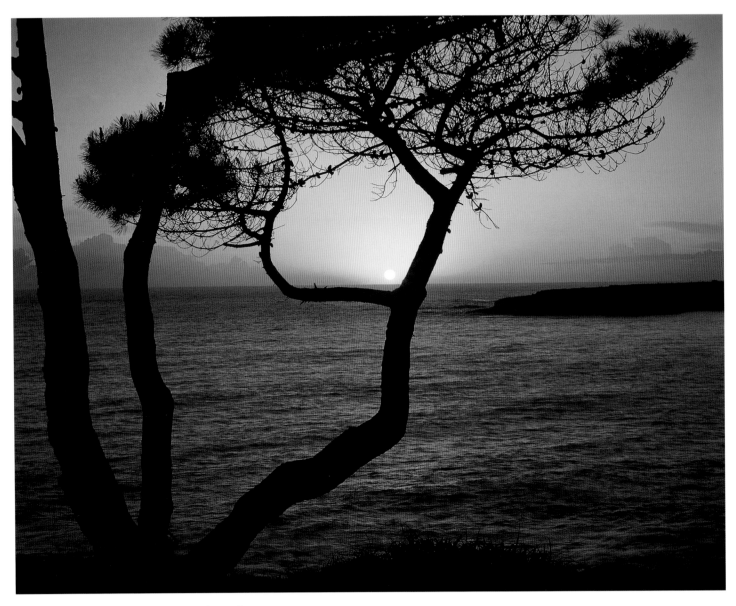

SUNSET AT MENDOCINO HEADLANDS STATE PARK

From Brewery Gulch Road, the setting sun outlines shore pines on the headlands.
A subspecies of the tall, straight lodgepole pines found at higher elevations in the mountains
of the west, shore pines' gnarled shapes reflect the influences of fog and ocean gales.

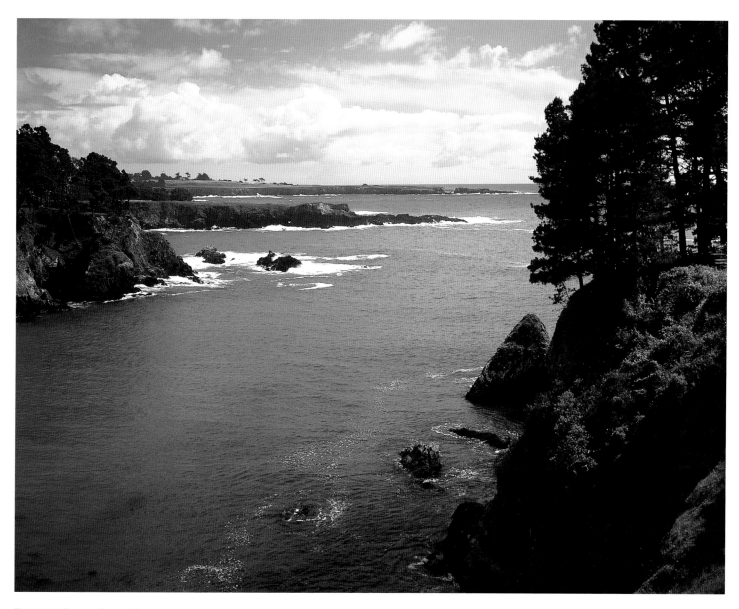

RUSSIAN GULCH STATE PARK

Thickly wooded headlands overlook a sparkling cove. Trails lead through forests and lush riparian habitats to the promontory where the Devil's Punch Bowl—a collapsed sea cave—noisily sloshes waves in its huge, rocky cauldron.

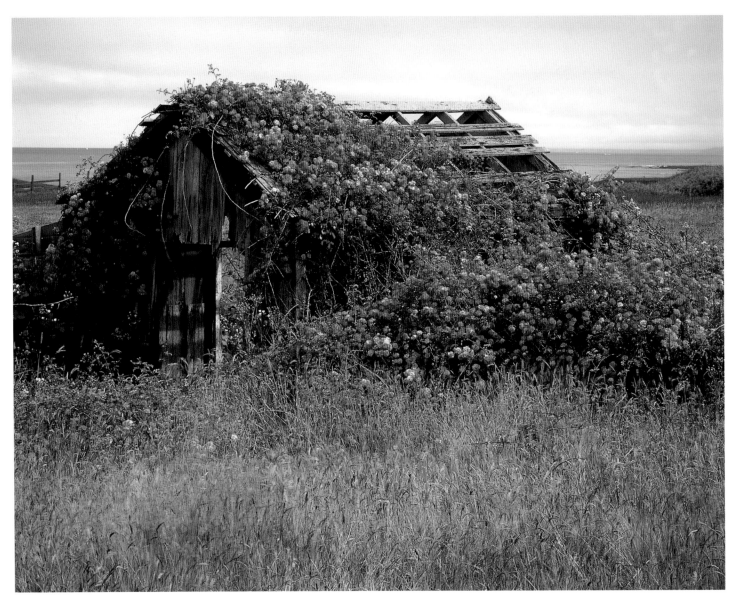

ROSE-COVERED REDWOOD SHACK

Wild and escaped garden roses enveloped this weathered redwood shack north of Fort Bragg. Until it finally collapsed in the mid-nineties, the structure was a favorite landmark to stop and photograph.

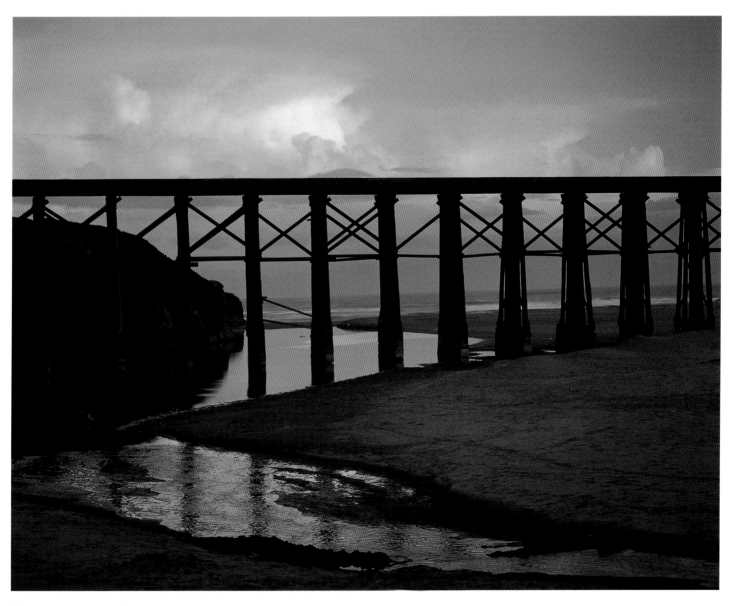

TRAIN TRESTLE OVER PUDDING CREEK

Trains once crossed this bridge to reach the lumber mill at Fort Bragg. A popular beach and picnic spot, Pudding Creek marks the southern boundary of MacKerricher State Park.

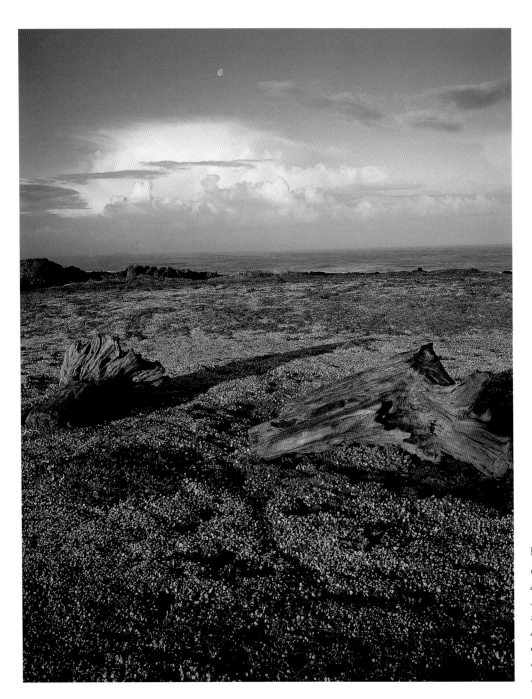

LAGUNA POINT

Coast goldfields bloom on a marine terrace above the wide beaches of MacKerricker State Park. The park protects rich and varied ecosystems of beaches and dunes, fens and marshes, and the fresh-water lagoon of Lake Cleone. A resident population of harbor seals inhabits Laguna Point, which is also a lookout for whale watchers.

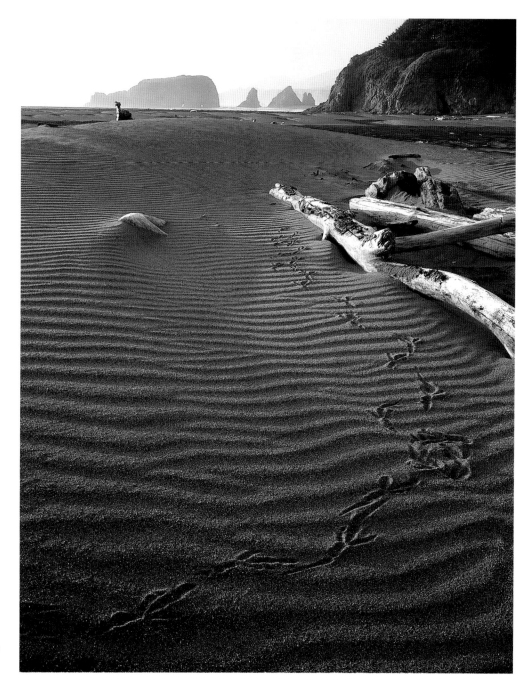

MOUTH OF THE TEN MILE RIVER

Raven tracks lead across driftwood-strewn sands of the upper reaches of MacKerricher State Park. Remnants of the old haul road leading to the Fort Bragg mill provide a popular route for walkers, joggers, and cyclists who traverse this stretch of coastline accompanied by the sounds of sea birds and powerful surf.

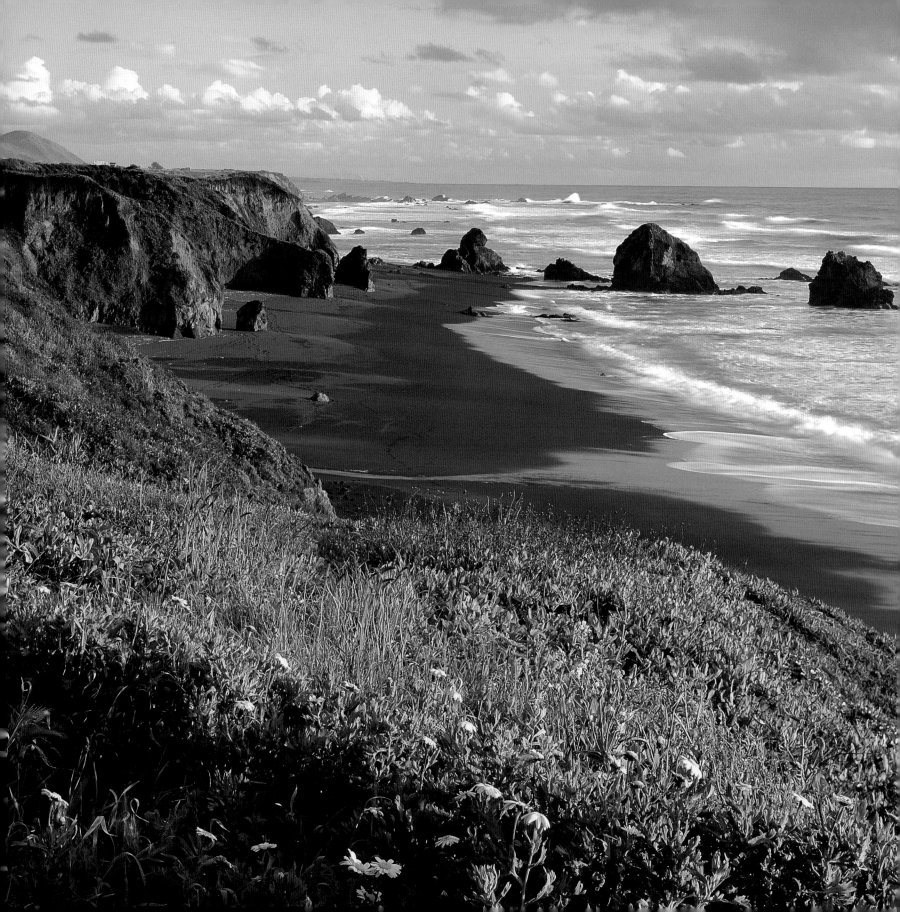

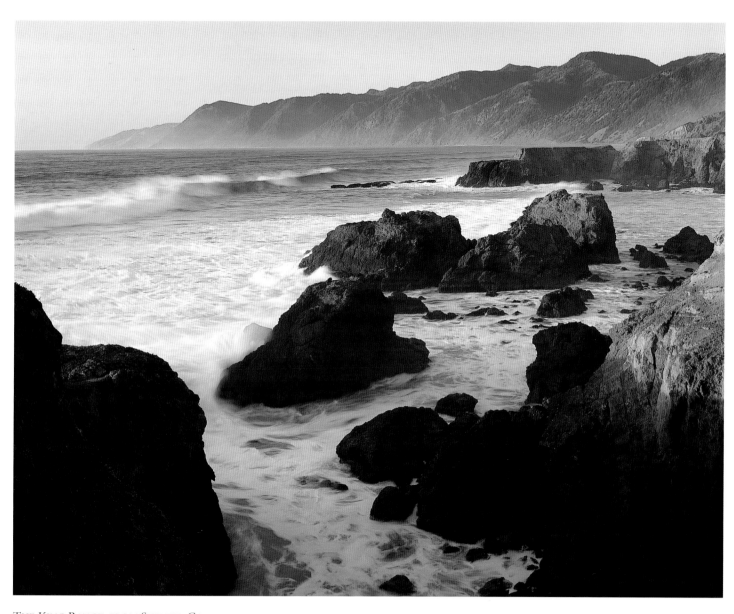

THE KING RANGE, FROM SHELTER COVE

North of Westport Highway 1 turns inland, leaving behind the rugged "Lost Coast." Its wild, remote landscapes are accessed by the adventuresome by a few tortuous mountain roads, a challenging section of the California Coastal Trail, and the fly-in resort at Shelter Cove.

SUNFLOWERS AT WESTPORT-UNION
LANDING STATE BEACH

87

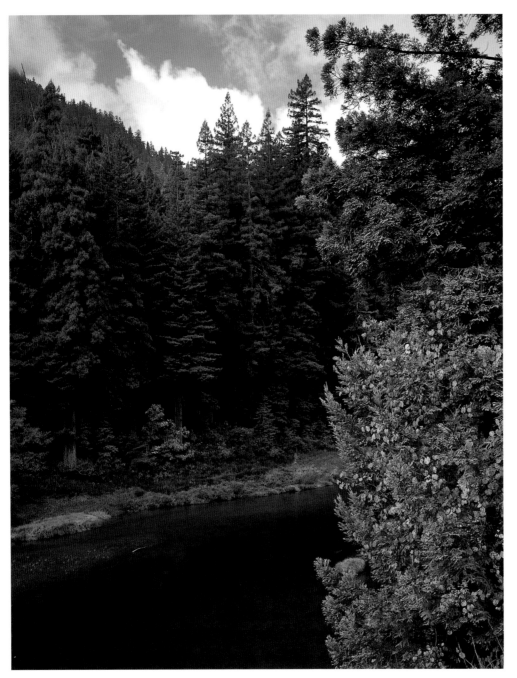

COAST REDWOODS ALONG
THE SOUTH FORK, EEL RIVER

*The Avenue of the Giants—one of the most
spectacular of drives anywhere—parallels
Highway 101 through Humboldt Redwoods
State Park along the Eel River's South Fork.
From its headwaters in Mendocino County
near Laytonville, the South Fork flows
northward past Leggett, Garberville, and
Weott to meet with the main Eel just north
of Founder's Grove. The erosive Eel
transports astonishing amounts of rock and
soil along its length, moving debris from
clearcuts and runoff from steep mountain
slopes downstream as it travels north and
east toward the sea near Ferndale.*

POISON OAK CLIMBS THE REDWOODS

Common throughout the redwood region, poison oak grows to epic proportions in open areas along the Mattole Road in Humboldt Redwoods State Park. Wrist-thick vines can climb hundreds of feet to the crowns of trees. Wrap your mind around it—but don't touch! All visitors should learn to identify poison oak (Toxicodendron diversilobum) with its clusters of three leaves. Its forms include small bushes, ground cover, tree-like shrubs, or high-climbing vines, and its foliage may be glossy green or tinged with red in spring and summer, turning bright scarlet and then yellow in the fall. In winter only dry stems remain, though its volatile oils so irritating to the skin are still present. "Leaves of three, let it be."

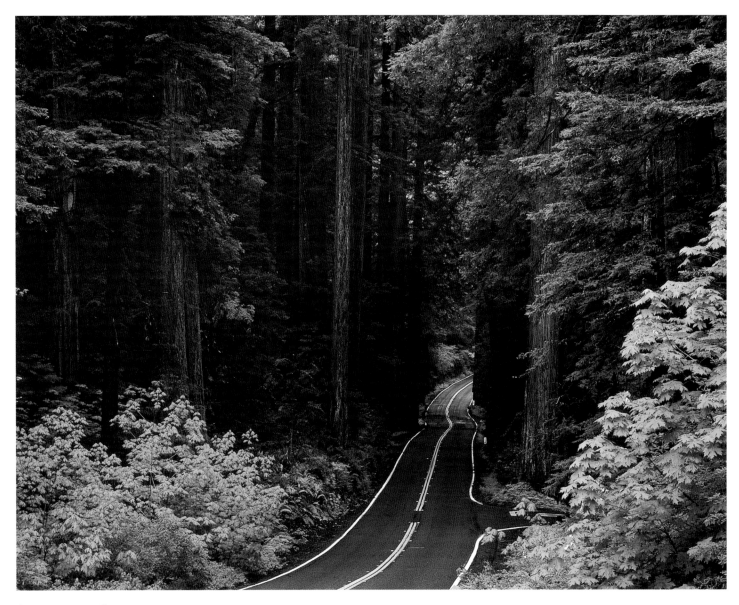

AVENUE OF THE GIANTS

Big-leaf maples and coast redwoods line the "scenic alternate" route through Federation Grove, Humboldt Redwoods State Park. The winding, two-lane road once offered the only route from San Francisco to the remote North Coast of Humboldt County.

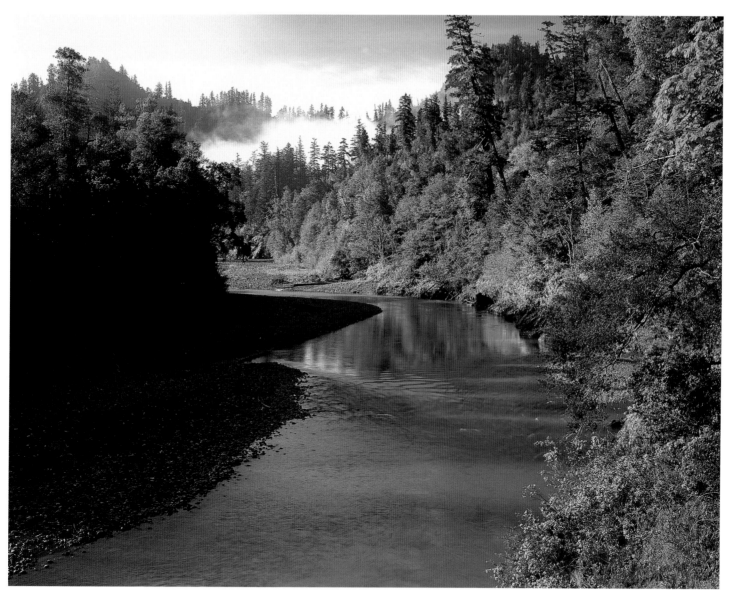

THE MAD RIVER, FLOWING THROUGH BUTLER VALLEY

One of six streams flowing out of the high ridges of Six Rivers National Forest,
the scenic Mad River boasts impressive steelhead runs and is popular with anglers.

VAN DUZEN RIVER VALLEY

From Bridgeville-Kneeland Road, the Larabee Buttes rise across the fog-filled river valley.
Native peoples burned meadows in this region to increase forage and make hunting easier.
When white settlers arrived, they found these "balds" ideal for raising cattle and sheep.

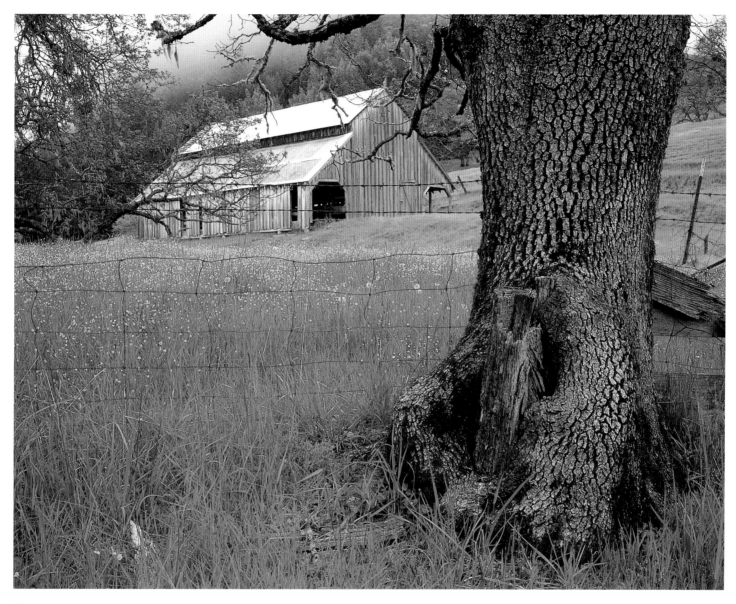

WEATHERED BARN ALONG HIGHWAY 36

A venerable Oregon white oaks' gnarled trunk, mossy branches, and silvery-white bark grace an old farmstead. Common on the North Coast, white oaks are valued for shade as well as for fencing, cabinetry, and construction.

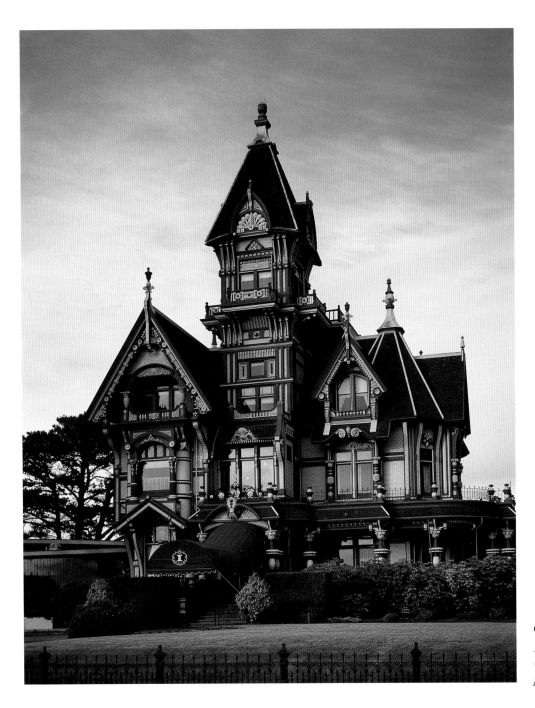

CARSON MANSION, EUREKA

Built in 1886 by lumber magnate William Carson, this ornate Victorian is now a private club.

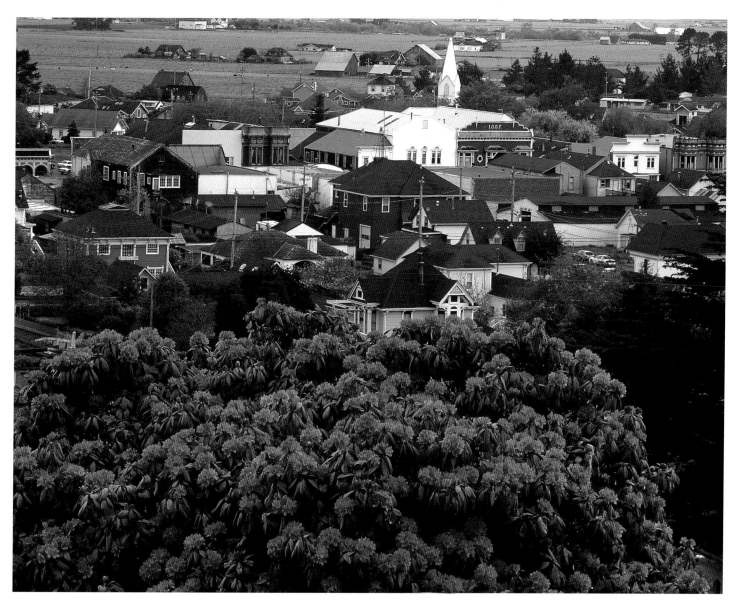

FERNDALE

Rich bottomlands of the Eel River have become pasturelands and dairies surrounding the village of Ferndale. Meticulously restored Victorians, eclectic shops and galleries, and cozy bed-and-breakfast inns welcome North Coast visitors.

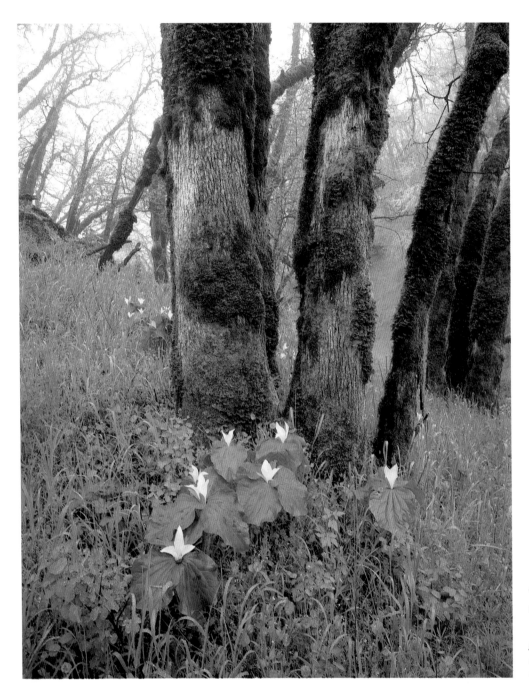

WHITE TRILLIUM AND
OREGON WHITE OAKS

White trillium is the most conspicuous and graceful of the array of wildflowers gracing bald hills and open prairies of the North Coast Ranges.

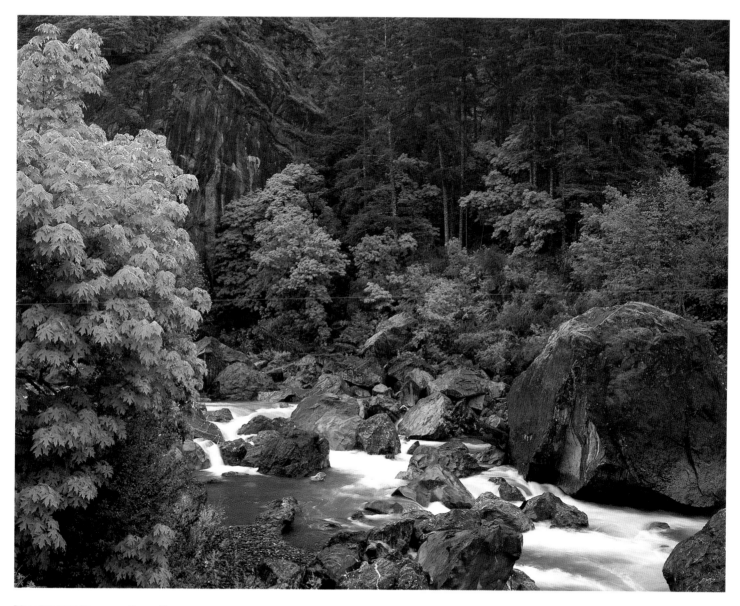

VAN DUZEN RIVER AT GOAT ROCK

Along Highway 36, an east-west scenic route across the Coast Range, the Van Duzen River flows west of Bridgeville toward its confluence with the Eel River near Fortuna.

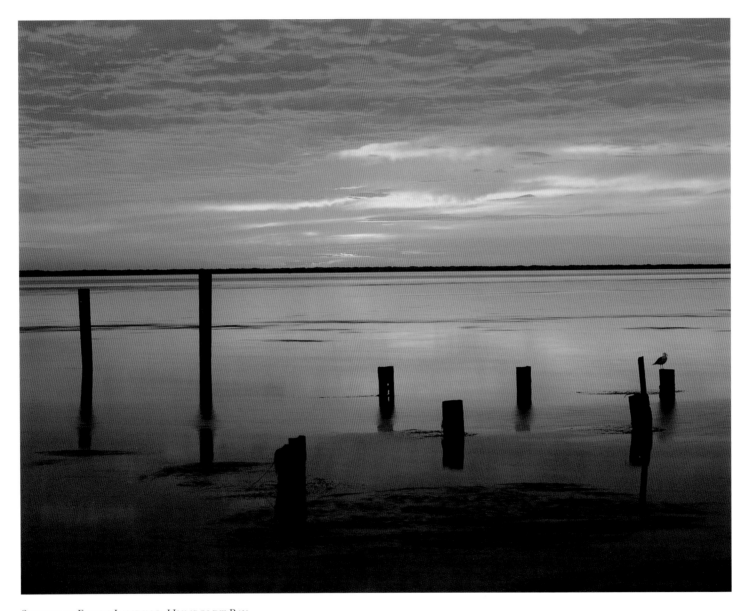

SUNSET AT FIELDS LANDING, HUMBOLDT BAY

Humboldt Bay, located on the Pacific Flyway, hosts vast numbers of migrating ducks and shorebirds who make these waters and adjoining Humboldt Bay National Wildlife Refuge their winter destination.

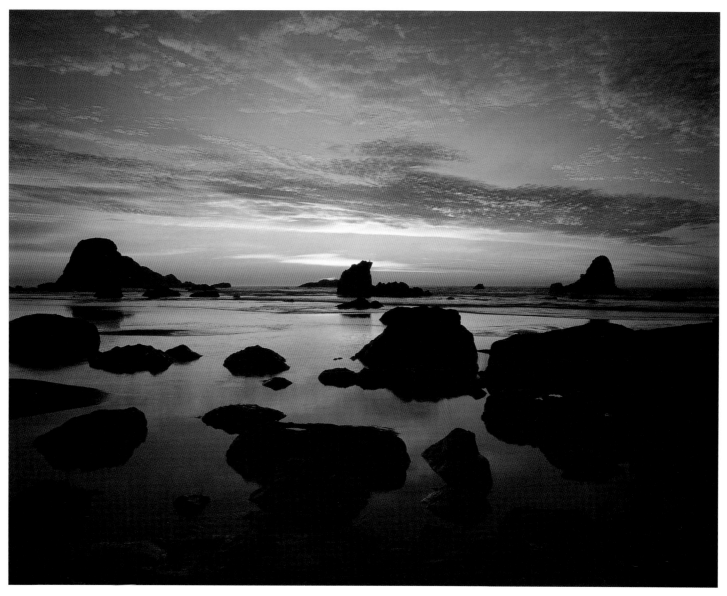

LITTLE RIVER ROCKS, FROM HOUDA POINT

Local residents call these prominent seastacks Camel Rocks as their shape describes two humps. With perfect conditions of swell and surf, Houda Point is the most popular surfing break on the North Coast.

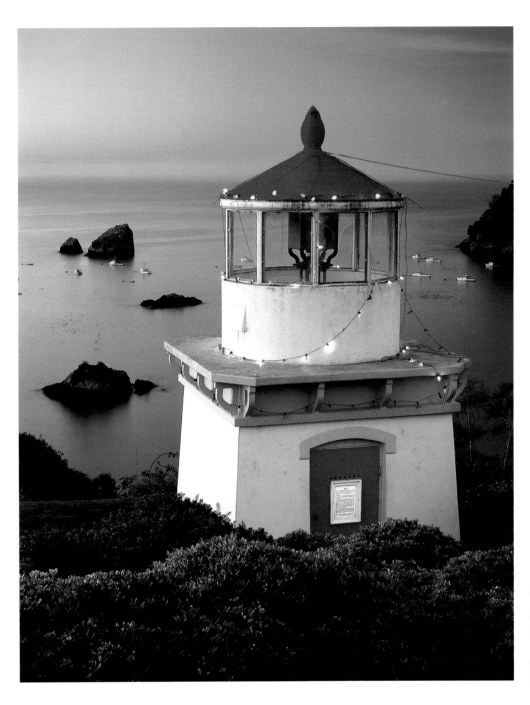

TRINIDAD MEMORIAL LIGHTHOUSE

Overlooking Trinidad Bay, this replica of the working light on the promontory of Trinidad Head commemorates fishermen lost at sea. Christmas lights go up during crab season.

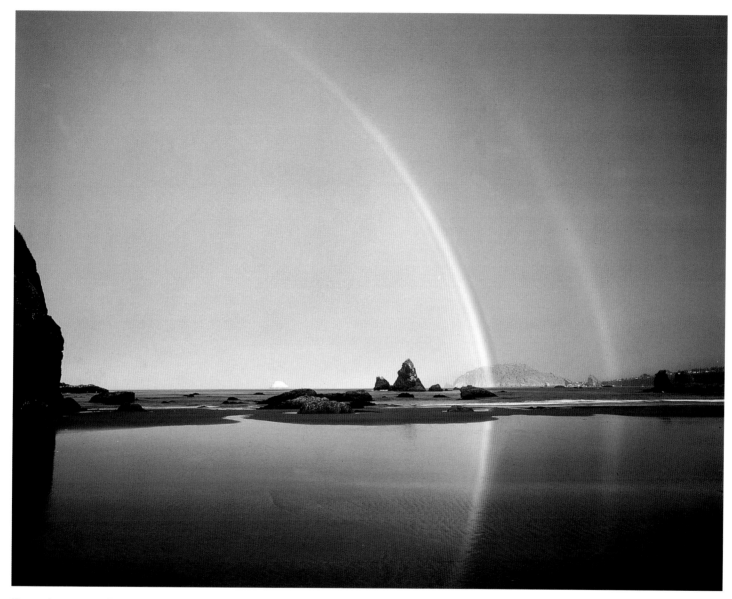

"Annie's Rainbow" over Trinidad Head

*One morning Larry and Donna's artist friend Annie pounded on their door,
shouting about an incredible double rainbow on the beach. They pulled pants
and jackets over pj's and arrived in time to catch this image.*

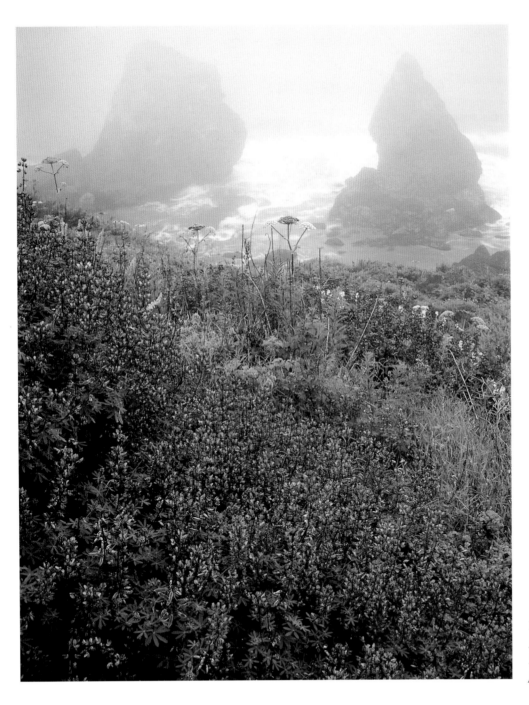

LUFFENHOLTZ BEACH COUNTY PARK

Summer fog envelops sea stacks below a headland carpeted with lupine and cow parsnip along Trinidad's Scenic Drive.

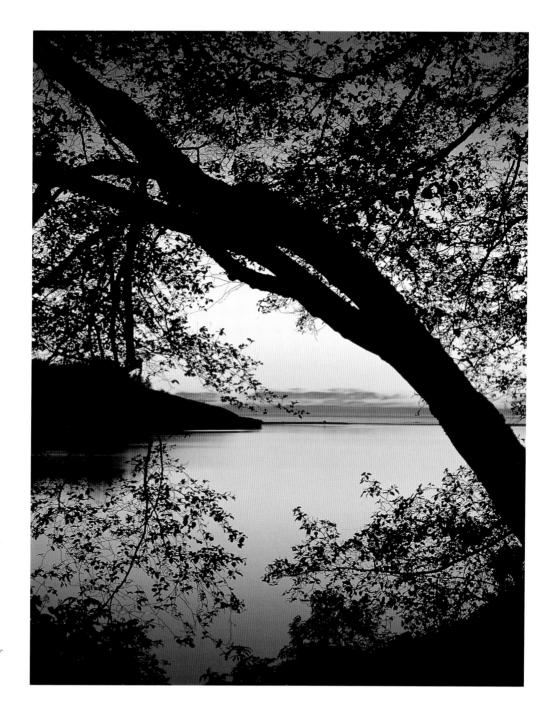

HUMBOLDT LAGOONS STATE PARK

Red alders frame sunset-still waters at Stone Lagoon, one of three lagoon estuaries protected by Humboldt Lagoons State Park. Lagoons along the stretch of coast north of Cape Mendocino formed when wave-carved sandspits blocked drowned mouths of stream valleys from the ocean. During winter storms, lagoon waters rise and the ancient streams still break through to the sea. In calm weather the lagoons offer peaceful retreats for canoeists, kayakers, and birders.

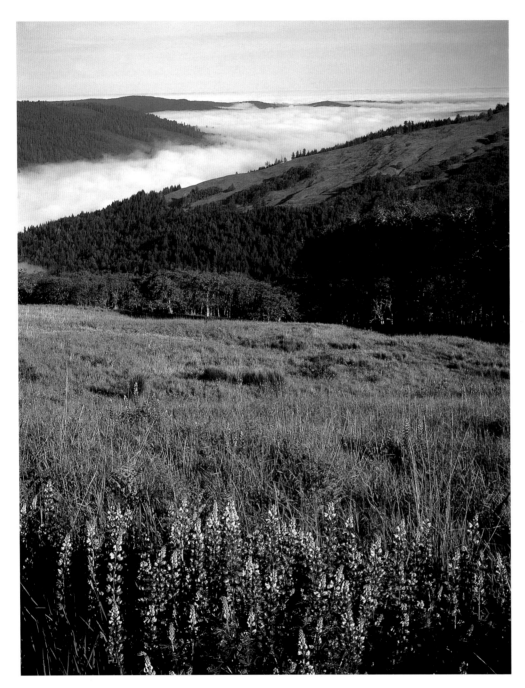

REDWOOD CREEK VALLEY
FROM SCHOOLHOUSE PEAK

Riverbank lupine and Oregon white oak scatter across open prairies along Bald Hills Road in Redwood National Park. Over 3,000 feet high, Schoolhouse Peak, the park's highest point, stands at the eastern corner of the park.

MORNING FOG FROM SCHOOLHOUSE PEAK,
REDWOOD NATIONAL PARK

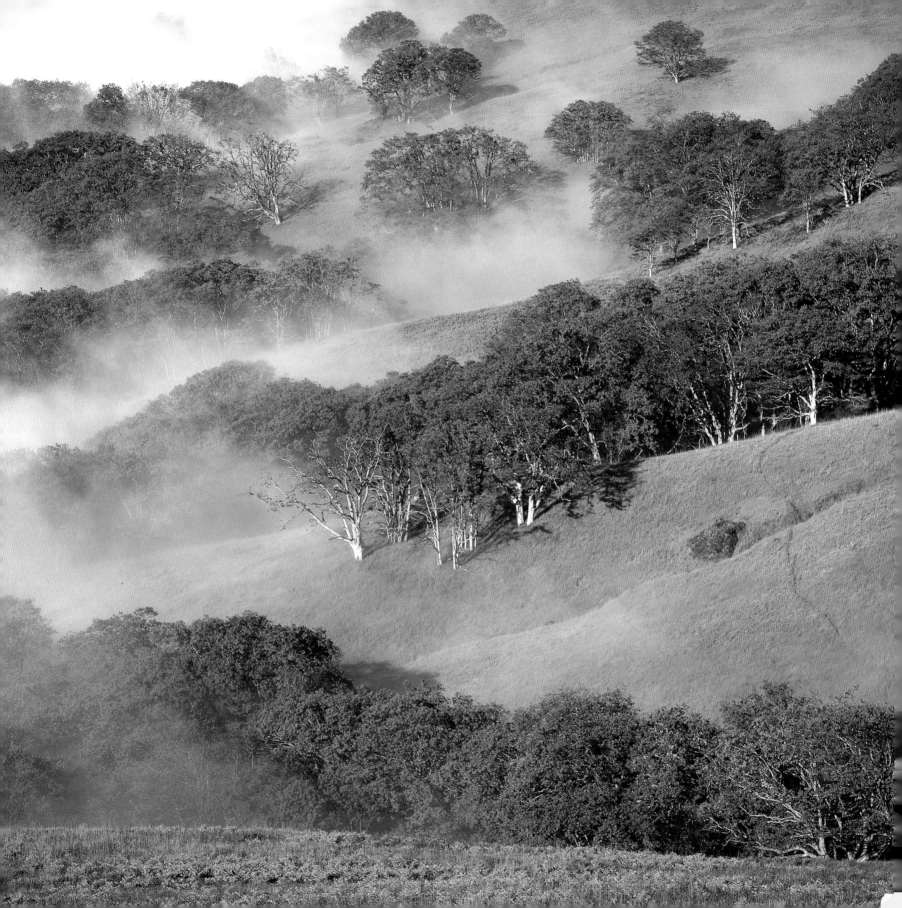

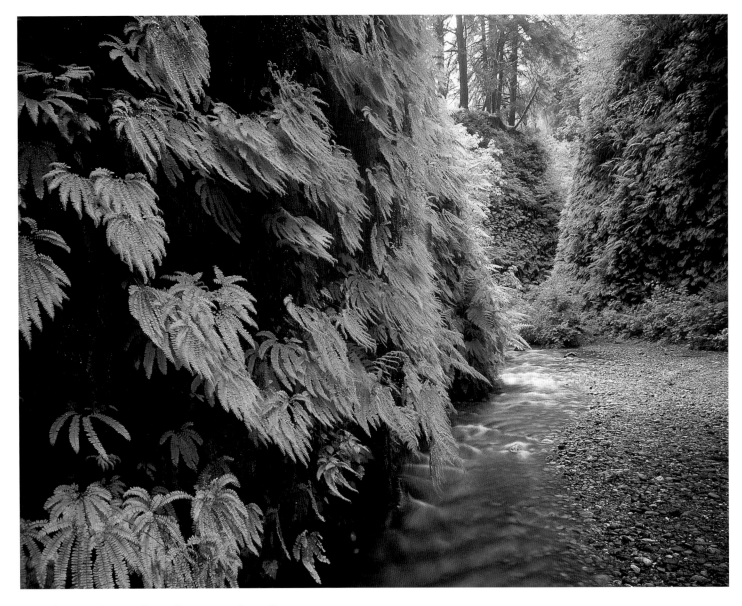

FERN CANYON, PRAIRIE CREEK REDWOODS STATE PARK

Five-finger ferns flourish on steep walls of Fern Canyon carved by the incessant waters of tiny Home Creek into a fifty-foot chasm. The creek's deeper pools provide habitat for coastal cutthroat trout.

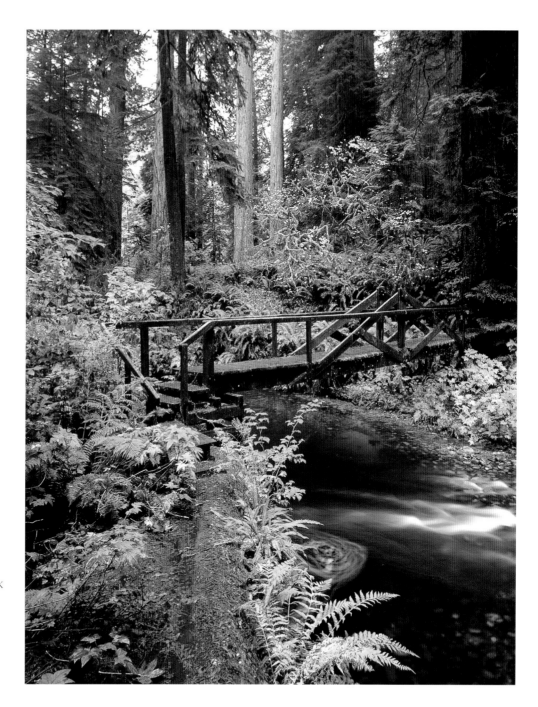

PRAIRIE CREEK REDWOODS STATE PARK

A rustic redwood bridge crosses Prairie Creek, one of the redwood region's cleanest running streams. Hikers may spot river otters, deer, and elk while walking trails through the park's pristine old-growth redwood groves.

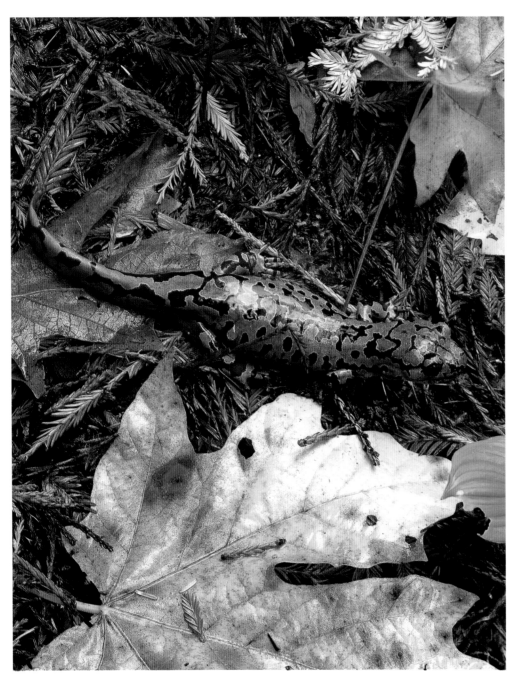

PACIFIC GIANT SALAMANDER

This handsome amphibian spotted along the Prairie Creek Trail marches through the damp habitat of a redwood forest floor. These salamanders may reach ten inches in length and will make squawking sounds if provoked. Larry and Donna observed a Pacific giant salamander eating a banana slug on one forest hike, a scene they describe as "the slimiest we have ever seen." Local human residents celebrate slugs in their own way. Annual Banana Slug Races at Prairie Creek Redwood State Park have been held the third weekend of August since 1968.

Opposite, clockwise from top left:

A chipmunk, mating banana slugs, a varied thrush, and a red-legged frog—all photographed in Redwood National Park.

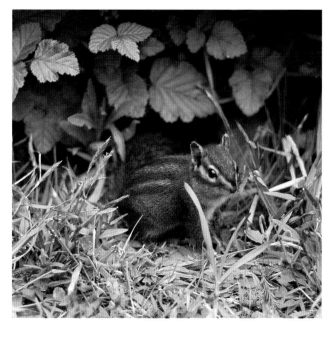

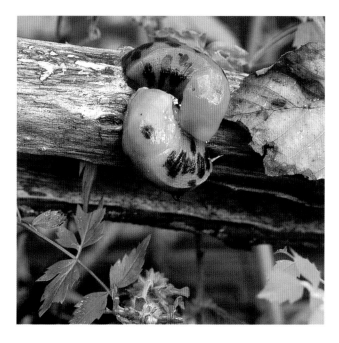

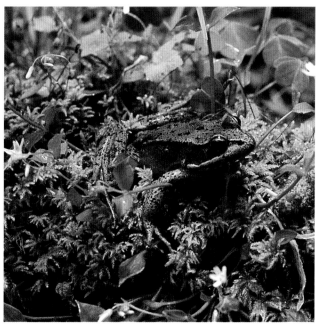

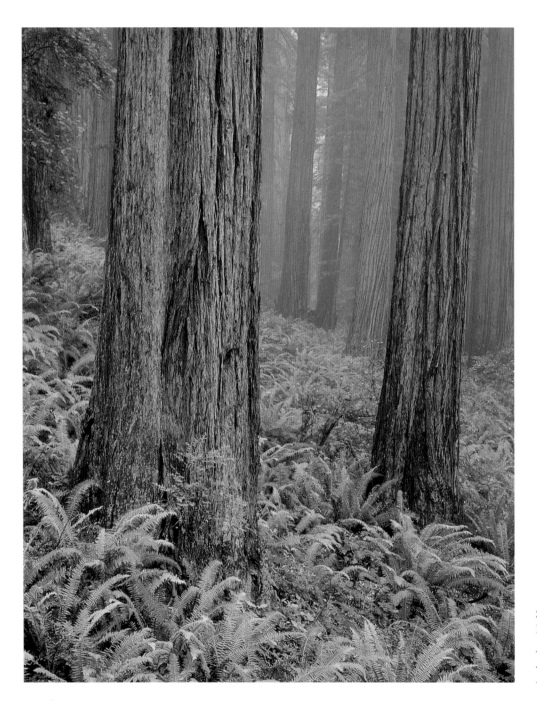

SWORD FERNS AND COAST REDWOODS,
EAST RIDGE FOREST

*Miles of trails wind among 300-foot,
2,000-year-old virgin redwood trees at
Prairie Creek Redwoods State Park.*

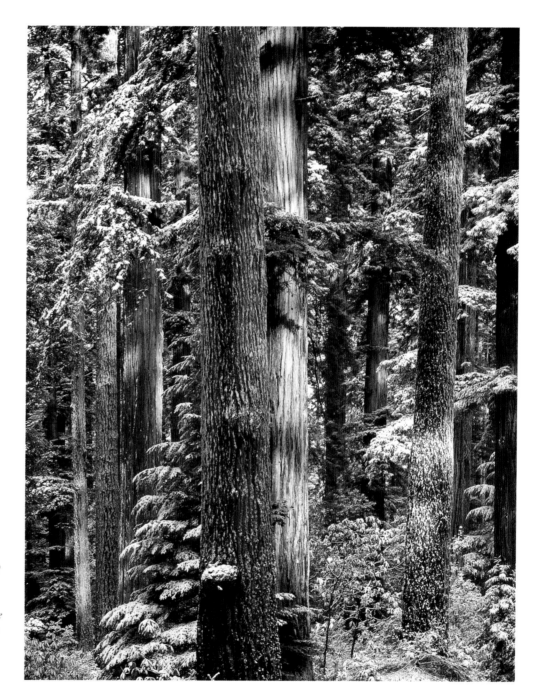

LADY BIRD JOHNSON GROVE,
REDWOOD NATIONAL PARK

*Snow does sometimes fall in the redwoods.
A late-February storm dusted this mixed
forest of redwood and Douglas fir at 1,400
feet along Bald Hills Road. Walking the
forest as the snow begins to melt can prove
a drenching experience. Snow caught in the
boughs overhead may suddenly drop on the
unsuspecting photographer below. Donna
advises taking an umbrella along in case
of snowfall.*

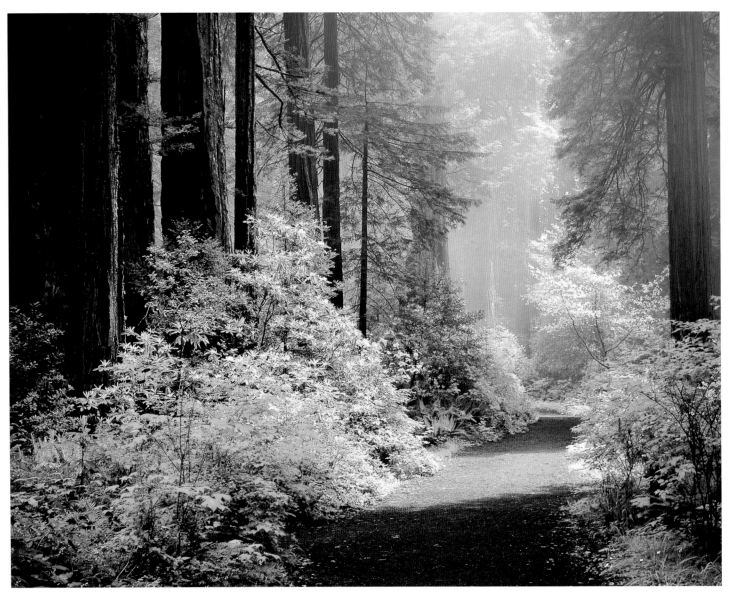

WESTERN RHODODENDRON AND COAST REDWOODS, REDWOOD NATIONAL PARK

Lady Bird Johnson Grove, named for the former First Lady who championed conservation of the redwoods, features accessible trails through majestic trees and splendid displays of rhododendrons in late May and early June.

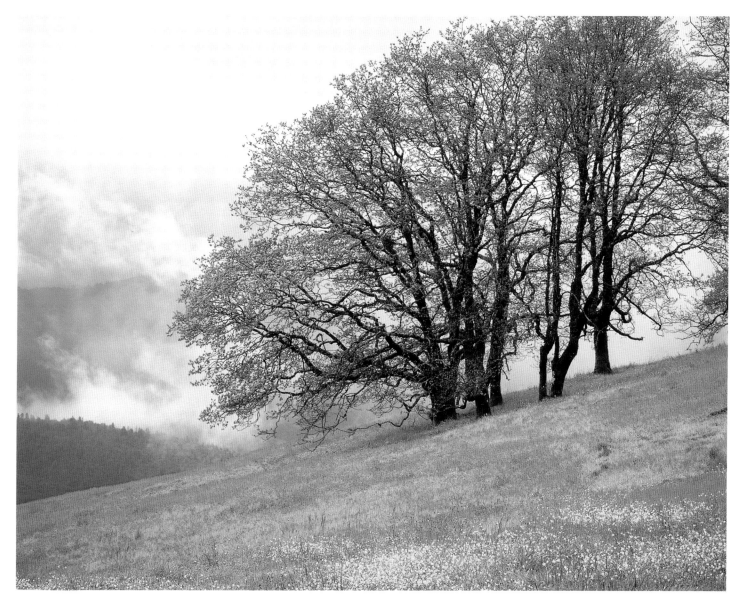

SPRING FROM SCHOOLHOUSE PEAK, REDWOOD NATIONAL PARK

Early May buttercups and sheep sorrel blanket oak-shaded hillsides of Redwood Creek Canyon, an area rich with varied wildflowers through spring—including fritillaria, larkspur, trilliums and more.

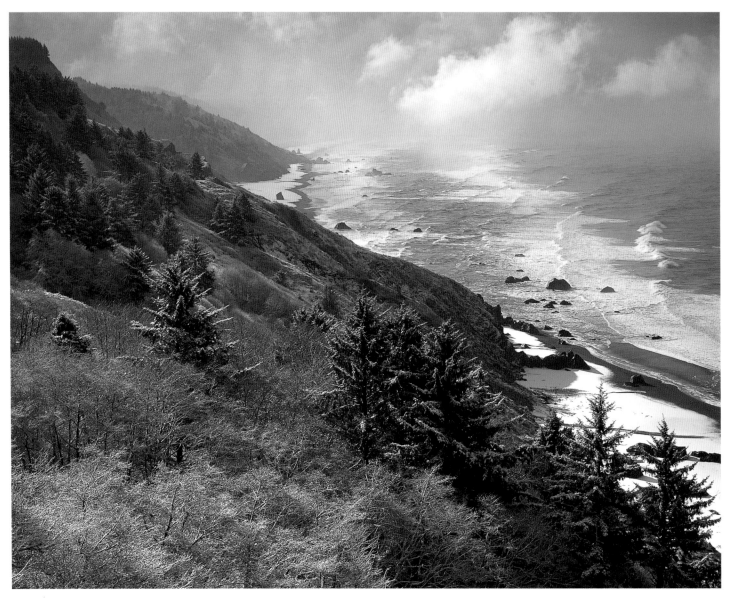

COASTAL DRIVE, REDWOOD NATIONAL PARK

After a February storm, snow cover all the way to tideline adds crisp detail to vistas south toward Carruther's Cove and Gold Bluffs Beach.

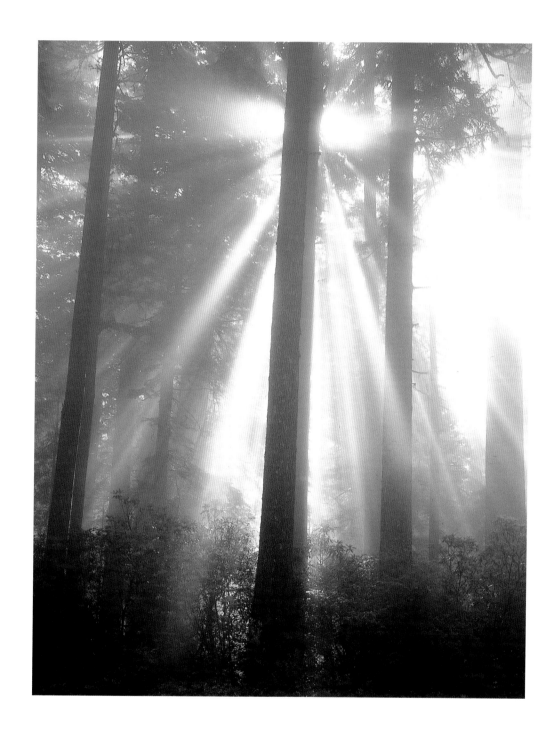

FOG ALONG HWY 101, DEL NORTE COAST REDWOODS STATE PARK

Rainfall in the redwood region can easily top over 70 inches each year, most of it falling from September to May. In summer, humid fogs provide crucial moisture redwoods need to thrive.

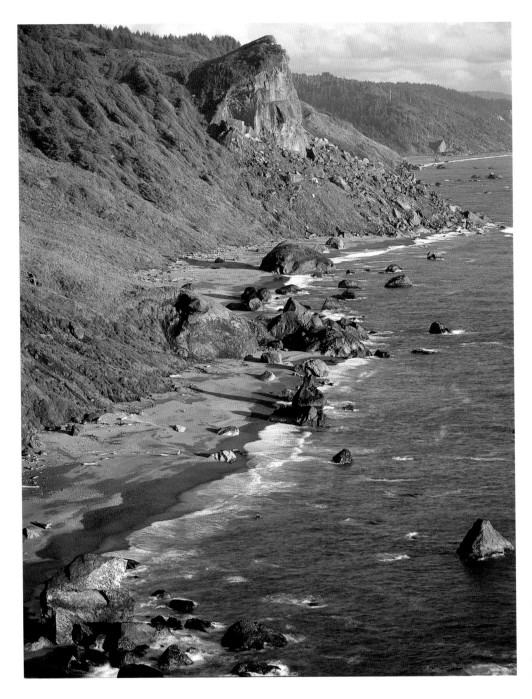

SPLIT ROCK, REDWOOD NATIONAL PARK

Viewed from High Bluffs Overlook on Coastal Drive in Redwood National Park, Split Rock rises steeply above the boulder-strewn beach. The rock is a sacred Yurok site.

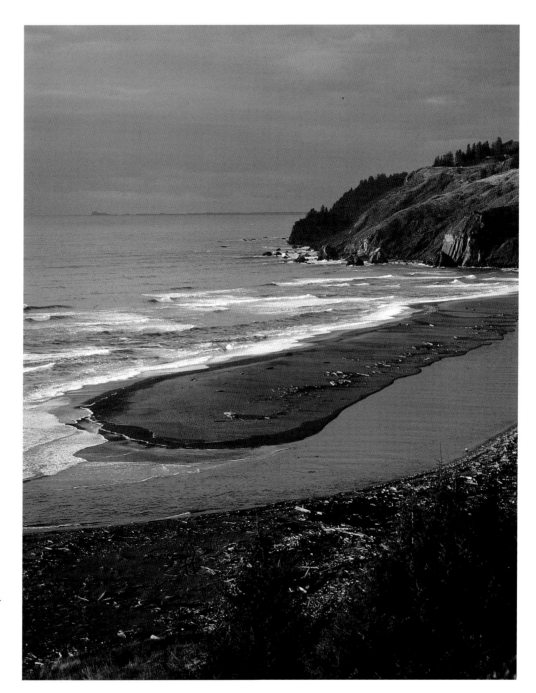

MOUTH OF THE KLAMATH RIVER,
REDWOOD NATIONAL PARK

The mighty Klamath flows south from its headwaters in the Cascade Range in Oregon, then merges with the Trinity River in the North Coast Ranges and takes a northward turn before flowing into the sea. In summer and fall the Klamath's impressive salmon and steelhead runs attract fishermen in droves.

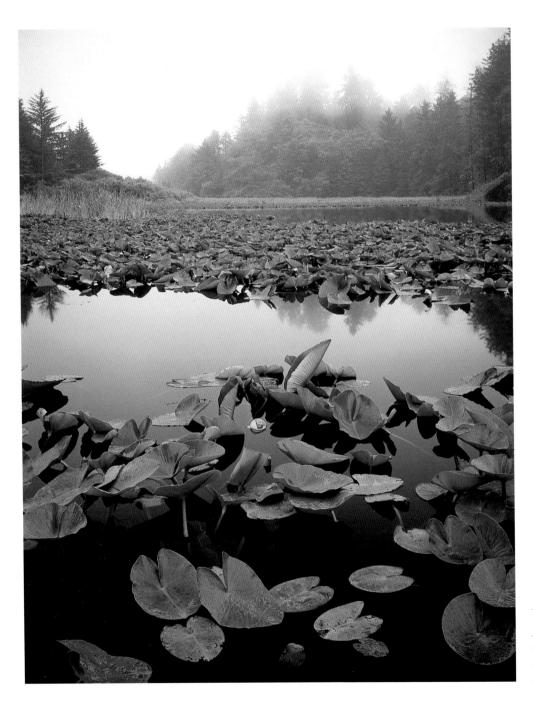

YELLOW POND LILY, LAGOON CREEK

A placid pond in Redwood National Park offers excellent habitat for blooming pond lilies and provides visitors peaceful fishing spots and picnic overlooks.

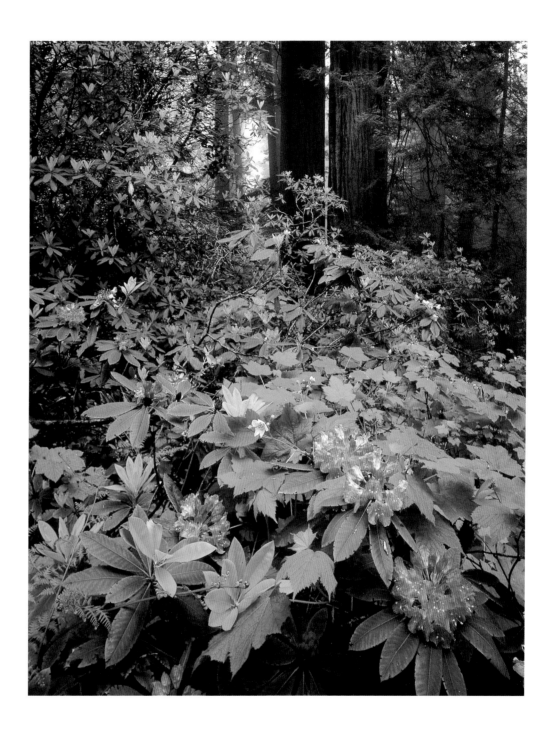

WESTERN RHODODENDRON

From late May through June, redwood forests of Del Norte Redwoods State Park burst with bright color from blooming Rhododendron macrophyllum.

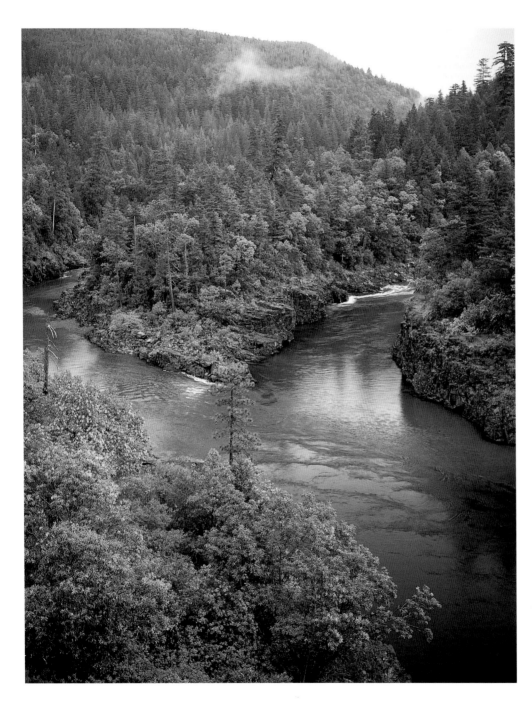

Smith River National
Recreation Area

*At the confluence of the South Fork
and Middle Fork of the Smith River, two
branches merge before taking an abrupt
turn north and emptying into the sea.
Renowned for its giant steelhead, the Smith
remains California's only undammed river.*

Above False Klamath Cove,
Redwood National Park

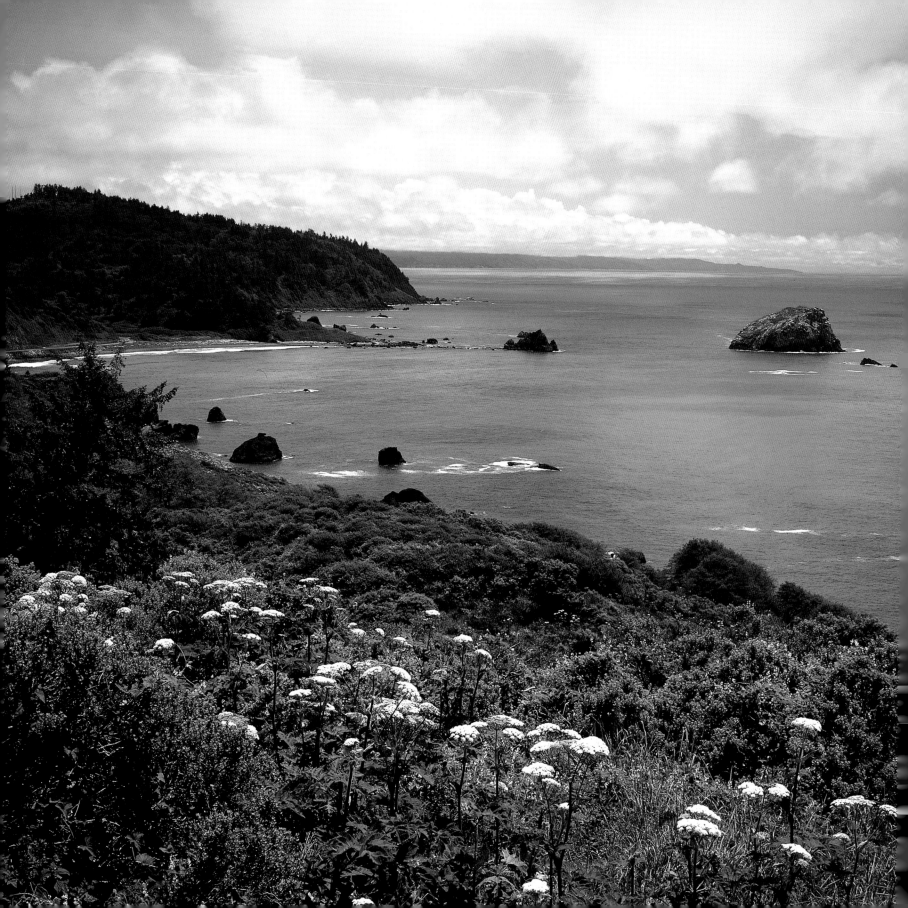

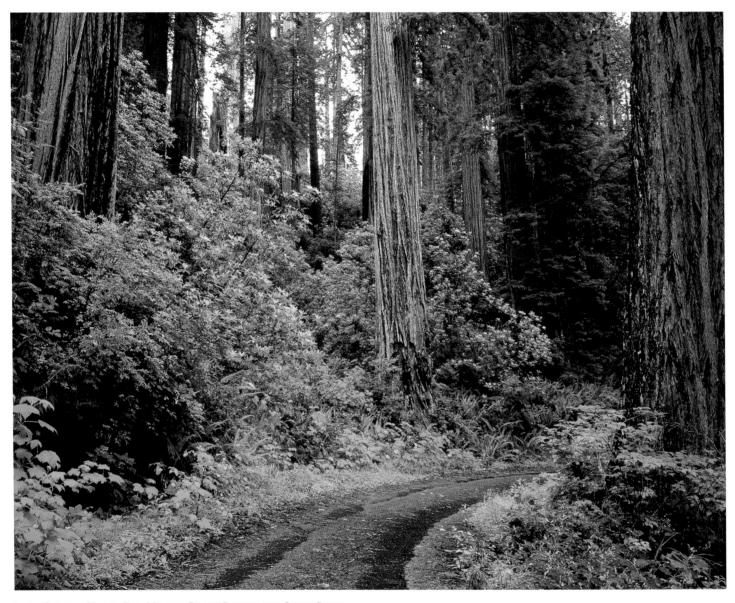

LAST CHANCE TRAIL, DEL NORTE COAST REDWOODS STATE PARK

Rhododendrons now flourish along this old roadway, the original route of Highway 101.
Hikers can reach the Last Chance Trail from the Damnation Creek Trail and traverse
the forests all the way to Enderts Beach in Redwood National Park.

DAMNATION CREEK TRAIL

One of redwood country's finest hiking adventures, Del Norte Coast Redwoods State Park's Damnation Creek Trail starts from a large pullout on Highway 101. The route gradually ascends the ridge, then plunges a thousand feet to a cobble-stone beach at the mouth of Damnation Creek. Hikers experience all of the plant communities of the North Coast on the way down and up.

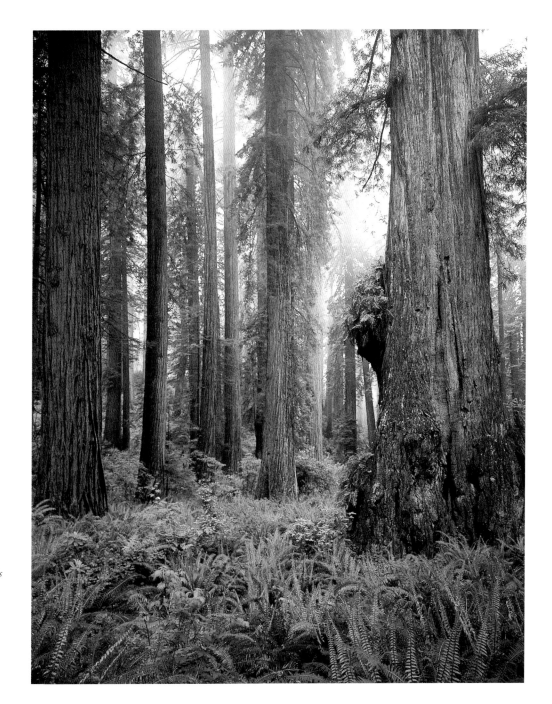

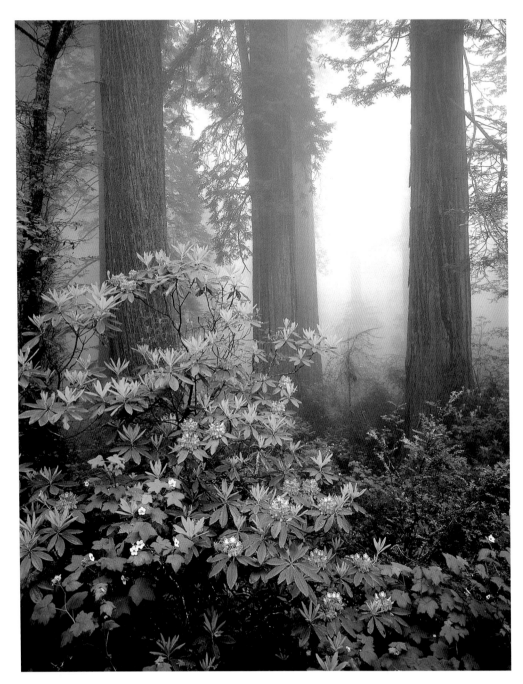

WESTERN RHODODENDRONS
AND COAST REDWOODS

*Last Chance Trail in Del Norte Coast
Redwoods State Park provides one of the
best locations to enjoy the jewel-like blooms
of rhododendrons, as showy as any award-
winning rose.*

MILL CREEK, JEDEDIAH SMITH REDWOODS STATE PARK

Mill Creek rushes through forests of big-leaf maple and coast redwoods on its way to meet the Smith River. Trapper/explorer Jedediah Strong Smith and his crew of eighteen mountain men set out from Sacramento toward Oregon in the spring of 1828. Their adventures led them through the challenging landscape of the Trinity and Klamath rivers, then north to the Smith River, which they named after their leader. The party continued their quest northward, perhaps abusing the native residents, before they were massacred on July 14. Only Jed Smith, away on a scouting mission, and two others escaped death that day. Smith was killed a few years later on the Santa Fe Trail, but the journal of one of his massacred men, Harrison Rogers, survived to relate the Smith party's exploits in this region.

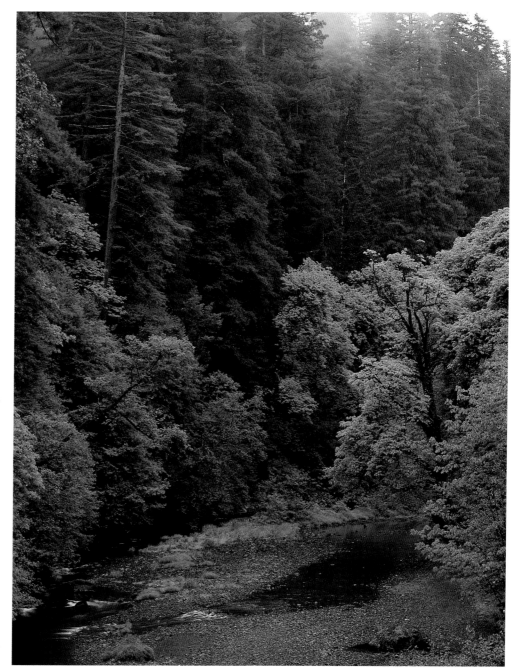

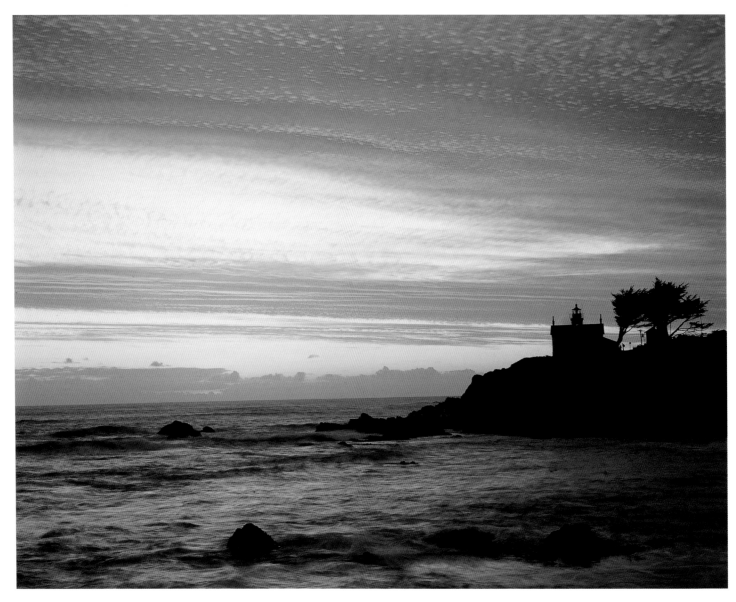

BATTERY POINT LIGHTHOUSE, CRESCENT CITY

The lighthouse at Battery Point has aided navigators since 1856. Perched on an island promontory reached by a narrow isthmus traversable only at low tide, the classic cozy structure evokes the romantic side of the lonely lighthouse keeper's existence.

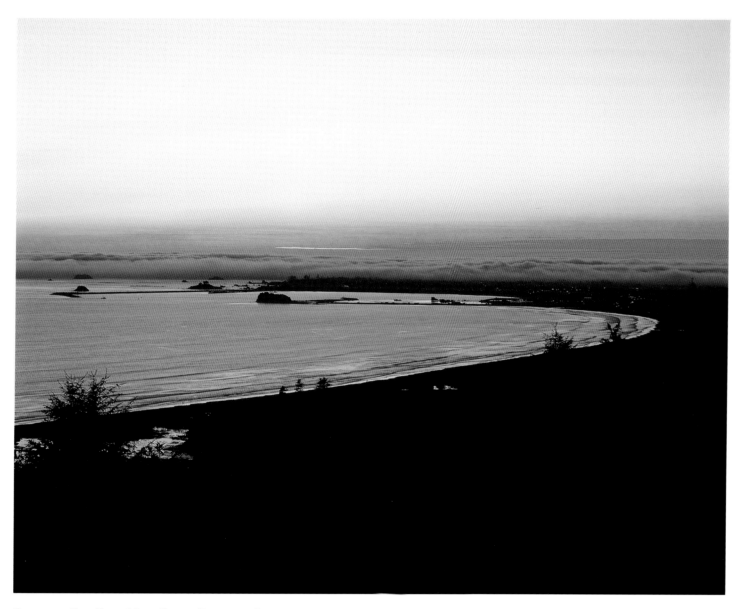

CRESCENT CITY FROM VISTA POINT, REDWOOD NATIONAL PARK

City lights emerge at sunset as an ever-present bank of coastal fog rolls in. Crescent City had to be reconstructed after tsunamis caused by Alaskan earthquakes in 1964 poured through seawalls and devastated its downtown district.

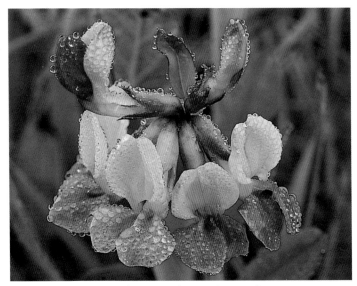

Seaside Lotus, Salt Point State Park

PHOTOGRAPHER'S NOTES

I used an assortment of photographic equipment in making these images of California's North Coast. My primary tools since 1975 have been several generations of Arca-Swiss view cameras which I shoot in 4x5, 2¼, and 2¾ formats. The 4x5 works best for the grand landscapes, the 2¼ and 2¾ for close-ups. Most 35mm work was done with a Nikkor 60mm f2.8 micro lens on a Nikon 8008. I often used a polarizing screen for the view camera shots to reduce glare and contrast. For much of the close-up work I used flexible loops stretched with fabric, called Flex Fills, both to shield my subject from the wind and create soft light by shading. I also modified a Bogen tripod to lay flat on the ground. The images in this book were shot with Fuji Velvia and Ektachrome E100S film. *—Larry Ulrich*